IMAGES
of America

HEALDSBURG

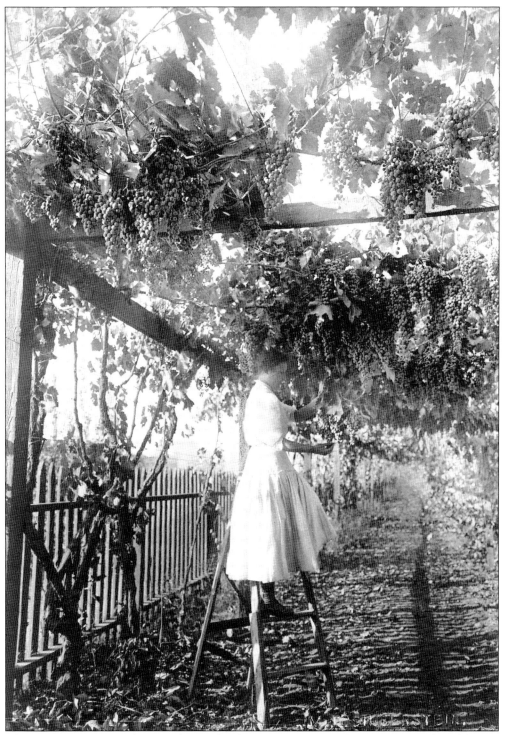

This charming *c.* 1910 photographic study of a young woman picking grapes for the table in a shady Healdsburg arbor is the work of Mervyn Silberstein. Silberstein was a popular photographer of Healdsburg who contributed many images for the town's early 1900s promotional materials.

IMAGES
of America

HEALDSBURG

Healdsburg Museum and Historical Society

ARCADIA
PUBLISHING

Copyright © 2005 by Healdsburg Museum and Historical Society
ISBN 978-0-7385-3060-4

Published by Arcadia Publishing
Charleston SC, Chicago IL, Portsmouth NH, San Francisco CA

Printed in the United States of America

Library of Congress Catalog Card Number: 2005929619

For all general information contact Arcadia Publishing at:
Telephone 843-853-2070
Fax 843-853-0044
E-mail sales@arcadiapublishing.com
For customer service and orders:
Toll-Free 1-888-313-2665

Visit us on the Internet at www.arcadiapublishing.com

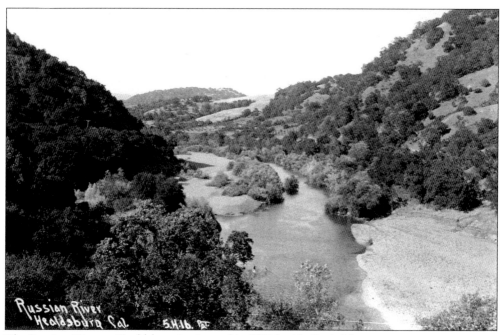

The Russian River at Healdsburg is pictured in 1916 beside Fitch Mountain.

CONTENTS

ACKNOWLEDGMENTS

This book would not have been possible without the volunteer effort of the many members of our community dedicated to the preservation and dissemination of the history of Healdsburg. Our contributors relied on museum archives, which contain a wealth of photographs, newspapers, records, and oral histories. They also received help from residents and others who generously shared their images. The book covers the first 100 years of our hometown's history.

We extend our appreciation to past president Bob Rawlins, who secured the original approval of the board of directors for the book project and has provided continuing assistance. Members of the publishing team include the following:

Elizabeth Holmes, image editor

Keith Power, text editor

Holly Hoods, research curator

Daniel F. Murley, curator

Charlotte Anderson and June Maher Smith, chief contributors

Anna Darden, Pat Keadle, Kay Robinson, Arnold Santucci, Sherrie Smith-Ferri, contributors

Pres. Al Loebel, administration and technical support

All images in this book, except as noted, are the property of the museum.

—Board of Directors
Healdsburg Museum and Historical Society

INTRODUCTION

The story of Healdsburg may be traced to a romance that began in the early 19th century.

Yankee sea captain Henry Fitch was a trader along the coast of California when it was under Spanish colonial rule and after Mexico's independence in 1821, when it became Mexican territory. In 1826, the dashing captain met Josefa Carrillo in San Diego. They fell in love but were denied permission to marry. The couple eloped, and ultimately their marriage was recognized. About 1844, Fitch, awarded Mexican citizenship in 1833, obtained a large land grant in what is now Sonoma County. He called it Rancho Sotoyome. During this Spanish-Mexican period, ranchos on the sparsely populated land raised cattle to produce hide and tallow as trading goods.

In 1846, war broke out between the United States and Mexico over a border dispute. The war ended in 1848 with the Treaty of Guadalupe-Hidalgo, which ceded California to the United States and guaranteed former Mexican citizens rights to property they held before the hostilities. A board of land commissioners was established in 1851 to judge the validity of Mexican land grants in the new State of California. In 1849, Fitch died in San Diego. His widow, Josefa Carrillo Fitch, and her nine children moved north to Rancho Sotoyome. She applied to the board for recognition of Fitch's land grant.

Meanwhile, the discovery of gold in California in 1848 provoked a wild scramble of prospectors into the Sierra foothills. Harmon Heald and his two brothers crossed the plains with thousands of other gold seekers and, like most of them, were disappointed at the diggings. Many of the newcomers settled without permission on land whose ownership was in dispute. Squatters invaded the Rancho Sotoyome and some required eviction later.

Heald built a cabin and a store on the site of what is now Healdsburg. The widow Fitch was declared in rightful possession of the rancho, but legal expenses and other debts forced her to auction off portions of the land. Heald bought the property and laid out the town's Plaza and its surrounding streets. In 1857, he filed a plat map of Healdsburg with county authorities, and 10 years later, the town was incorporated.

The story of the original inhabitants of the land involves going back in time thousands of years. The first chapter of this book introduces these resourceful people.

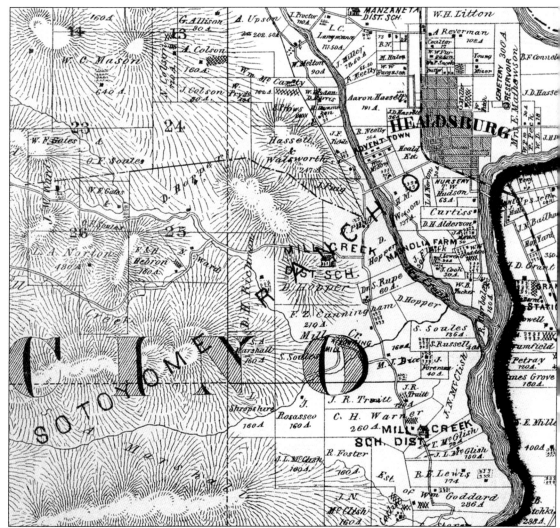

This 1877 map from the *Sonoma County Atlas* shows the major landowners and landmarks in the Healdsburg area between Litton (Lytton) Springs and Eastside Road. In addition to the locations of former one-room schoolhouses, the 1877 map shows that Healdsburg had a large Seventh-day Adventist settlement, "Advent Town," located west of the town in the Dry Creek Valley.

One

FIRST PEOPLE

Southern Pomo and Western Wappo peoples have been linked to this land for thousands of years. Before photographs or written records, the Russian River (*Ashokawna* in Southern Pomo), its tributary, Dry Creek (*Mihilakawna*), and a generous landscape provided the first peoples and their descendants with a varied and abundant diet. When Europeans first appeared in the Russian River valley in the 1820s, the Southern Pomo village *Kale* existed where the Healdsburg Plaza is today, in the shadow of *Tsuno* (Fitch Mountain). Disruption of Native American culture and settlement patterns began with the establishment of Spanish/Mexican missions in Northern California in the early 1800s and was intensified by the waves of gold seekers and settlers in the 1850s.

After thousands of years of stability, the Southern Pomo and Western Wappo population in the Healdsburg vicinity declined drastically, dropping from an estimated 8,500 people in the 1840s to barely 100 people by 1916, due to newly introduced diseases. The loss of hunting and gathering territory, forced labor, relocation to Mendocino County reservations, and other hardships also took a heavy toll. Most survived by working as migrant agricultural laborers on local ranches. Descendants of these first peoples continue to live and work in the local area. To this day, the Southern Pomo and Western Wappo peoples retain strong personal ties to their homeland and cultural heritage.

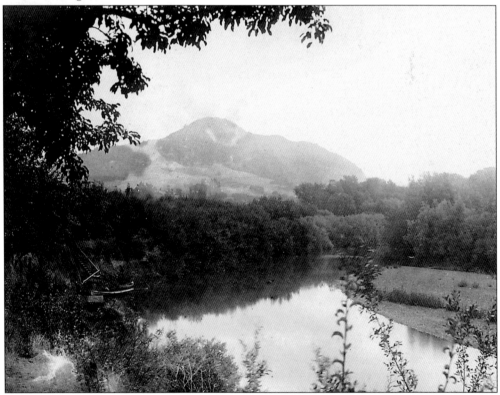

This serene image of the river and the mountain evokes a previous time, before roads and bridges were built and new names were given to the old names.

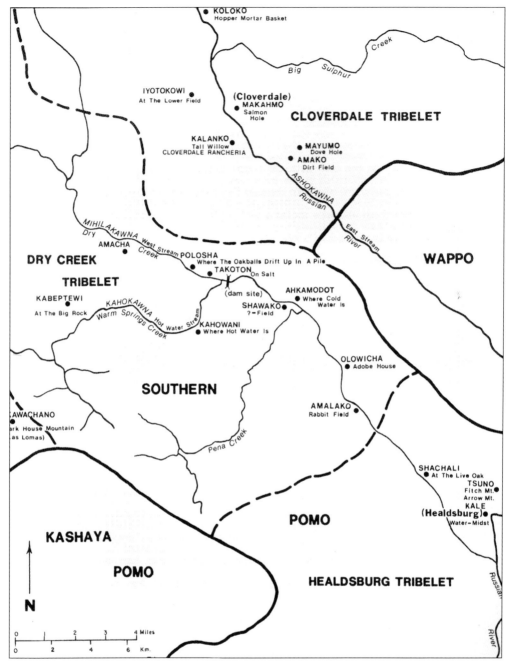

KOLOKO
Hopper Mortar Basket

IYOTOKOWI
At The Lower Field

(Cloverdale)
MAKAHMO
Salmon
Hole

CLOVERDALE TRIBELET

KALANKO
Tall Willow
CLOVERDALE RANCHERIA

MAYUMO
Dove Hole

AMAKO
Dirt Field

ASHOKAWNA
Russian

East Stream
River

WAPPO

MIHILAKAWNA
Dry West Stream Creek

AMACHA

POLOSHA
Where The Oakballs Drift Up In A Pile

TAKOTON
On Salt

(dam site)

DRY CREEK

TRIBELET

KABEPTEWI
At The Big Rock

KAHOKAWNA Hot Water Stream
Warm Springs Creek

AHKAMODOT
Where Cold
Water Is

SHAWAKO
?–Field

KAHOWANI
Where Hot Water Is

OLOWICHA
Adobe House

SOUTHERN

AWACHANO
ark House Mountain
as Lomas)

AMALAKO
Rabbit Field

Pena Creek

SHACHALI
At The Live Oak

TSUNO
Fitch Mt.
Arrow Mt.

KALE
(Healdsburg)
Water–Midst

POMO

KASHAYA

POMO

HEALDSBURG TRIBELET

Russian River

N

| 0 | | 2 | | 3 | | 4 Miles |
| 0 | 2 | | 4 | | 6 | Km. |

The archaeological record of the Healdsburg area indicates that Native Americans have lived in this region for at least 12,000 years. In the more recent past, Southern Pomo speakers have resided in the vicinity of Healdsburg and Dry Creek Valley. Western Wappo–speaking peoples, who were culturally very similar to the Southern Pomo, lived in Alexander Valley and Geyserville. For generations, they lived in settled, independent villages within recognized home territories. (Map by Terry A. Jackson, 1984.)

This unidentified Southern Pomo man, photographed in front of a fishing weir at the Russian River near Healdsburg, holds two willow fish traps that he probably made himself. Weirs (fences of woven stakes and shoots) were erected seasonally to help block passage of steelhead and salmon. Fish traps would then be placed in front of the weirs. The double-mouth design of the trap allowed fish to enter, but prevented their escape. (Courtesy of the University of Pennsylvania Museum of Archaeology and Anthropology.)

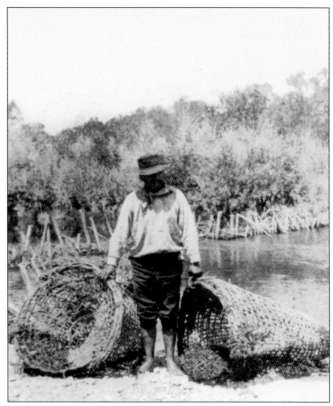

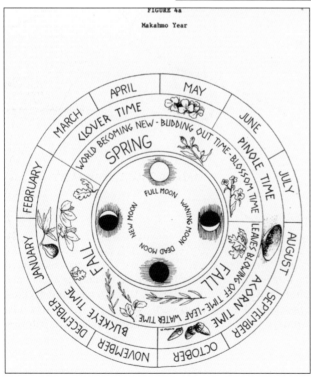

FIGURE 4a

Makahmo Year

Life for the successful hunter-gatherers was closely tied to the seasons. As food resources became available throughout the year, indigenous women gathered and processed berries, seeds, nuts, roots, greens, mushrooms, and tubers. Large quantities of food were collected and stored, to be eaten during the winter months. Men fished and hunted deer, elk, rabbit, other mammals, and birds. (Illustration by Rusty Rossman, 1984.)

11

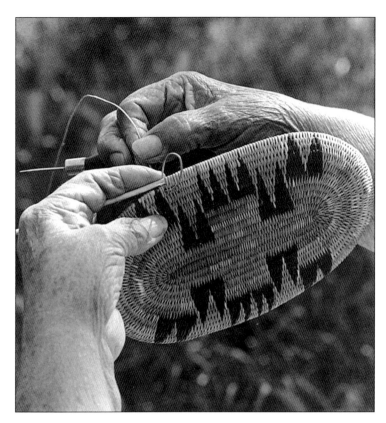

Artfully combining form and function, the Southern Pomo and Western Wappo are credited with weaving some of the most complex and beautiful baskets in the world. Laura Fish Somersal, a renowned basket maker of Geyserville Wappo–Dry Creek Pomo ancestry, became a consultant late in life, helping to share and preserve the language and cultural traditions of her people. (Courtesy of the estate of Scott M. Patterson.)

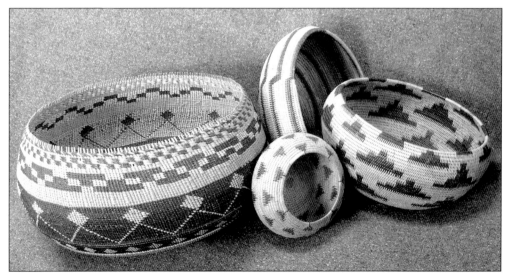

Unlike most basketmaking peoples, Southern Pomo and Western Wappo used both major basket-weaving techniques—coiling and twining. Men and women wove baskets, although generally men wove the simpler "work" baskets. The women were the acknowledged artists. Willow and redbud shoots, and sedge, pine, and bulrush roots were used to create the many designs. Feathers and beads were sometimes added for extra adornment. (Courtesy of Daniel F. Murley.)

Local weavers made a variety of utilitarian baskets to use in harvesting, catching, carrying, cooking, and storing staple foods, such as acorns, salmon, and seeds. Native women fashioned cradle baskets to carry their infants, and exquisite gift baskets to commemorate special events. Pictured here about 1905 are Emma Jeff Manuel and son Frank. A cradle basket enabled a mother to have her hands free while carrying her baby snugly and securely on her back.

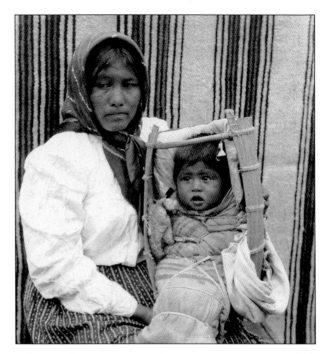

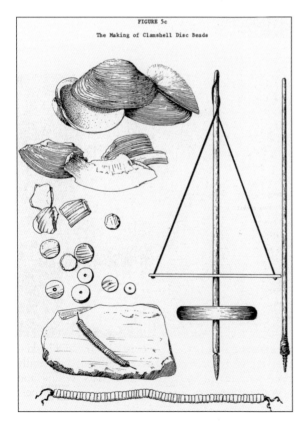

FIGURE 5c

The Making of Clamshell Disc Beads

For both Southern Pomo and Western Wappo, beads were a sign of wealth and status. They were worn as jewelry and used as currency. Pomo men were accomplished bead makers. To make clamshell disc beads, they drilled holes in pieces of shell using a pump drill with a metal tip, like the one pictured here. Earlier they used a handheld drill with a stone tip. (Illustration by Rusty Rossman, 1984.)

13

Maria Copa Freas, left, is pictured in 1927 at the Alexander Valley Rancheria. When the U.S. government established the Alexander Valley Rancheria in 1909 and the Dry Creek Rancheria in the Alexander Valley in 1915, the small land allotments did little to change the marginal conditions of native life. Most local Pomo and Wappo continued to subsist as migrant laborers.

Elizabeth Dollar and her children, Ruth, Gilbert, and Lena, were photographed in 1925 at the Dry Creek Rancheria in Alexander Valley. Dry Creek and Stewarts Point were the only rancherias in Sonoma County that did not vote for termination when the Rancheria Act was passed in 1958. Other local bands lost their recognized tribal status when they voted to end ties to the government and transfer rancheria land to private ownership. (C. Hart Merriam photograph; courtesy of Bancroft Library, University of California, Berkeley).

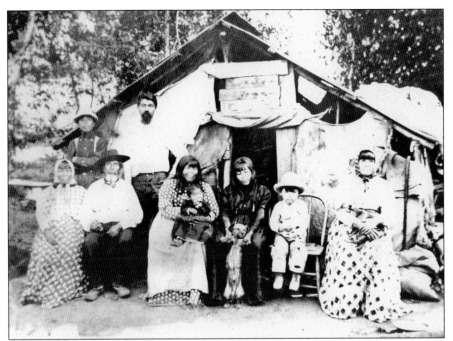

In the early 1900s, most native people in the area worked and lived on ranches in exchange for wages and crops, supplementing their diets with whatever traditional foods they could still hunt and gather. This unidentified local family, photographed in front of their dwelling around 1910 by Mervyn Silberstein, worked on the Grant and Minaglia ranches on what is today Bailhache Avenue.

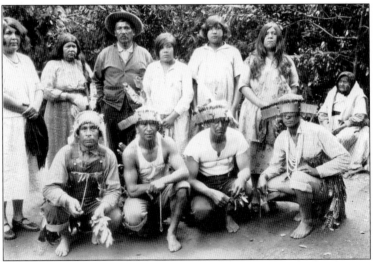

Music and dance were, and still are, integral to Pomo and Wappo cultural life. Seasonal ceremonies, featuring feasting, singing, and dancing, are traditionally celebrated to maintain spiritual balance, give thanks, and renew the world. Dancers wear elaborate regalia, such as the men pictured here in flicker feather headdresses, c. 1928. Their dance imitated precisely the movements of birds. Pictured here, from left to right, are (first row) Henry Arnold, Manuel Cordova, Mike Cordova, and Alfred Elgin; (second row) Elizabeth Dollar, Maggie Waho, Jack Waho, Emma Lozinto, Ruth Cordova, and Lizzie Waho. Mary Lucas is at right in the background.

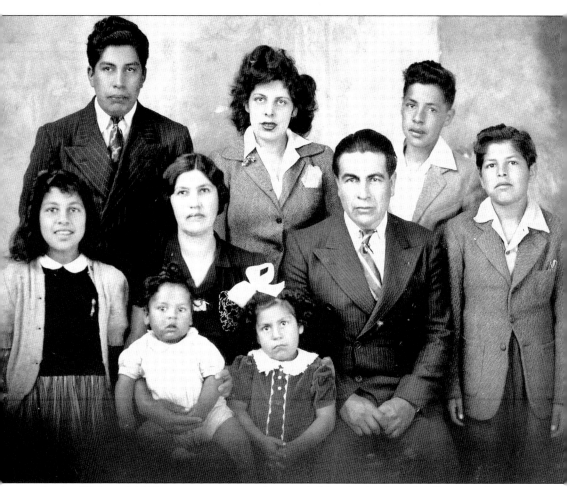

In the 1930s and 1940s, many native people attended local schools and colleges, and entered nonagricultural careers. In 1942, the Smiths, a prominent Dry Creek Pomo family, hired S. E. Langhart to take this portrait. Bill Smith established the Native American Studies departments at Sonoma State University and Santa Rosa Junior College. His siblings also distinguished themselves in their respective fields. Smith descendants still live in the Healdsburg area. Pictured here, from left to right, are (first row) Douglas and Kathleen Smith; (second row) Marceline (Marcy), Lucy Lozinto, Steve Smith, and Stanley Smith; (third row) Russell, Geraldine (June), and William (Bill) Smith.

Two

BRAVE OLD DAYS

Healdsburg was the idea of a young pioneer merchant, Harmon Heald, who in the early 1850s set up a store on the site of the present town to serve miners taking the main trail to the northern Sierra gold diggings. Another American, Cyrus Alexander, was there before him in the 1840s as ranch manager for Capt. Henry Delano Fitch of San Diego. Fitch, a Yankee sea trader, became a Mexican citizen and acquired the vast Rancho Sotoyome. After the American takeover of California, Fitch's widow, Josefa Carrillo Fitch, moved to the rancho with her large family. She was obliged to sell off portions to pay family debts in 1856 and one of the buyers was Heald. In 1857, he laid out the new town around a plaza.

Alexander was a success as Fitch's agent and was rewarded with the fertile valley north of town that bears his name. He became one of the affluent citizens of Healdsburg in its early years, as did Roderick N. Matheson, a prominent landowner and civic benefactor. Matheson was visiting Washington, D.C., when the Civil War broke out in 1861. He joined the Union army as an infantry colonel and died in battle at age 38. His remains were given a hero's burial in Healdsburg's Oak Mound Cemetery.

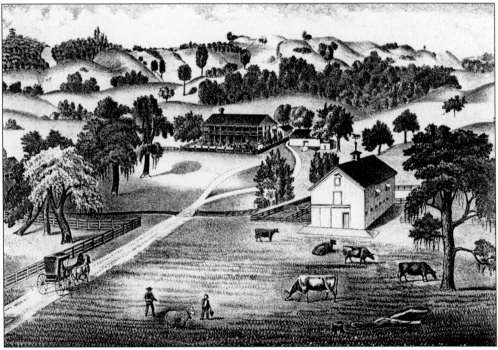

Cyrus Alexander's early enterprise as a pioneer rancher in the Alexander Valley made him a rich man. This impressive home, depicted in the 1877 Sonoma County Atlas, was built for his wife, Rufena Lucero, whom he married in 1844. They moved to the home in 1845 and subsequently had 12 children. In 1877, the home was occupied by the widowed Mrs. Alexander, her husband having died in 1872.

In 1825, Henry Delano Fitch, a Yankee sea captain trading along the west coast of South American and Mexico, put into the Mexican port of San Diego. He converted to Roman Catholicism and prevailed over local authorities to marry the beautiful, young Josefa Carrillo. In 1833, Fitch became a Mexican citizen. He acquired from Mexican officials some 48,800 acres of land in Northern California.

Josefa Carrillo fell in love with Capt. Henry Fitch in San Diego and eloped with him to Valparaiso, Chile, where they were married in 1829 when she was 18. They returned to San Diego in 1830 with a son. The Mexican authorities allowed them to "legally" marry and the couple had 10 more children. Fitch died in 1849, never having seen the land he had acquired in Northern California. His widow and nine of their children moved to the Rancho Sotoyome in what is now the Healdsburg region. She died in 1893.

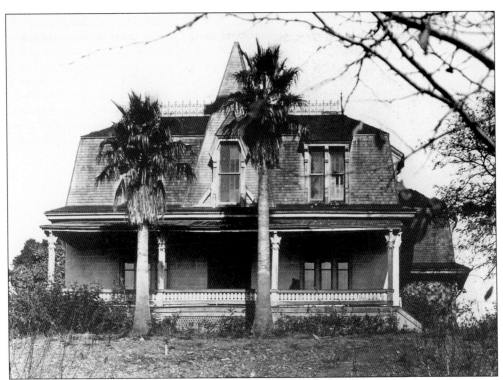

The original home on this site south of the Russian River was built of adobe blocks in 1844 by pioneer Cyrus Alexander for the owner of the land, sea captain Henry Fitch of San Diego. The house was occupied by his widow, Josefa Carrillo Fitch, and their children. In 1878, "Fitch's Castle" was remodeled to contain 17 rooms. It burned down in 1913. The two palm trees remain today.

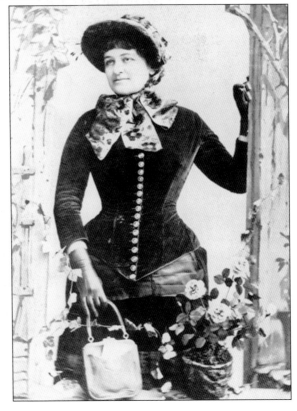

Anita Fitch Grant, shown here at the height of fashion, c. 1883, was born in 1848 in San Diego to Capt. Henry Delano Fitch and Josefa Carrillo de Fitch. She and her siblings were taken by the widowed Mrs. Fitch in 1850 to the vast family rancho in what is now the Healdsburg region. She married John Delano Grant, a former gold seeker and prominent citizen. She died at age 84 in 1933, survived by four children. Courtesy of Sonoma County Library.)

19

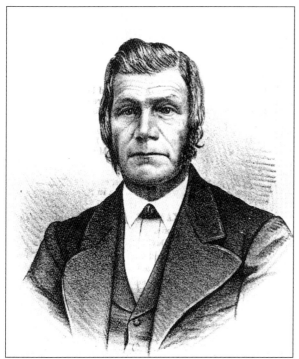

Cyrus Alexander was the first American settler in what became the Healdsburg region. He arrived in 1840 to scout out territory obtained by Capt. Henry Fitch from the Mexican authorities. Fitch then hired Alexander to develop Rancho Sotoyome. In return for his success in this venture, Alexander claimed the wine-growing valley that bears his name. In 1872, he died at his valley ranch.

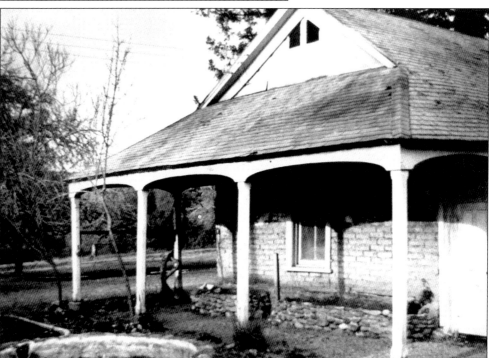

Pioneer settler Cyrus Alexander built an adobe home in what became the Alexander Valley. The main building was severely damaged in the earthquake of 1906 and demolished. An adobe structure survived and has since been restored and enlarged. This contemporary photograph shows the adobe outbuilding prior to restoration by owners Harry and Maggie Wetzel.

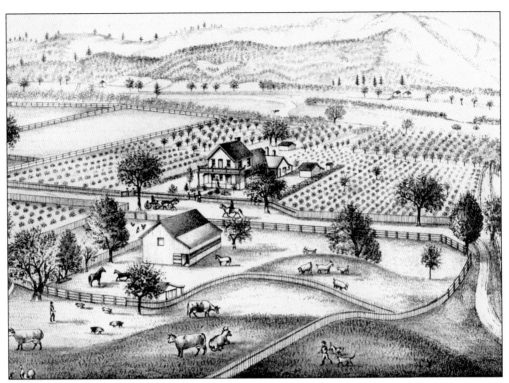

The depiction of Duval D. Phillips's home and abundant farm land in the Dry Creek Valley appeared in the *Sonoma County Atlas*, 1877. Eleven years earlier, he and a partner bought 132 acres from Jose German Piña, who owned the Tzabaco Rancho, a 17,000-acre Mexican land grant. The sale included Piña's adobe house, which later was incorporated into the new two-story house.

Josefa Carrillo Fitch was the widow of Capt. Henry Fitch, who obtained a large land grant in Northern California during the Mexican era. After the American takeover, she was forced to sell property on the Sotoyome Rancho to pay off family debts in 1856. The legal owners brought suit to evict squatters on the land, and eventually force was brought to bear in the short-lived "Squatters' War."

Guardian's Sale.

STATE OF CALIFORNIA, } ss.
In Probate Court, Sonoma County. }

BY VIRTUE OF AN ORDER AND DEcree of this Court, made on the 5th day of February. A. D. 1856, I. Josefa Carrillo de Fitch, guardian of Joseph Fitch, Josaphine Fitch, John Fitch, Isabel Fitch, Charles Fitch and Anna Fitch, shall proceed to sell all the right, title and interest of said Joseph Fitch, Josaphine Fitch, John Fitch, Isabel Fitch, Charles Fitch and Anna Fitch, in and to the remaining and unsold portion of the Rancho and Lands called Sotoyome, containing about nine square leagues of land, situated in the counties of Sonoma and Mendocino, in said state of California. The said sale will take place at the Court House door, in the town of Santa Rosa, on **Monday the 25th day of August, A. D., 1856,** commencing at 11 o'clock in the forenoon of that day. The said Rancho and Lands will be subdivided into small tracts of convenient size for farming purposes, and sold in separate subdivisions. The terms of sale will be, one third cash, and the balance on a credit not exceeding three years, secured by bond and mortgage on the land, at an interest of one per cent. per month, payable semi-annually.

JOSEFA CARRILLO DE FITCH,
51-3w Guardian, &c.

21

Healdsburg's founder, Harmon Heald, left Missouri to come to the California gold fields but ended up in Sonoma County. He chose a location on the main road, built a small cabin, and soon added a small store. The site he chose was to become the town of Healdsburg, and his cabin was located on West Street (now Healdsburg Avenue). Heald laid out the town and donated land for the Plaza and lots for a school, cemetery, and churches. Heald did not live to see his town develop; he died of consumption in 1858 at the age of 34 years.

Sarah Heald Shaw, the sister of Healdsburg's founder Harmon Heald, was a single young woman when she joined her brothers in California in 1851. She married T. A. Shaw in 1852 and lived in the Healdsburg settlement where her son, Thomas, the first of three children, was born in 1853. Widowed in the 1860s, she raised her family in Cloverdale.

In 1861, Roderick N. Matheson, a prominent landowner and civic benefactor of Healdsburg, traveled to Washington, D.C., seeking a political appointment. Instead, the Civil War started and he enlisted in the Union Army. Infantry colonel Matheson was killed in battle the following year at age 38. His remains were buried with great ceremony in Healdsburg's Oak Mound Cemetery.

In 1844, Antoinette "Netty" Seaman married Roderick N. Matheson in New York City. She is pictured here with her infant son Roderick Jr., who was born in 1849. His father hoped that Roddy would attend West Point, but that wasn't to be. Roderick Jr., died in a threshing machine accident in the Sacramento Valley. After Colonel Matheson was killed in the Battle of Crampton's Gap in 1862, Netty lived in the Matheson home in Healdsburg until her death in 1884.

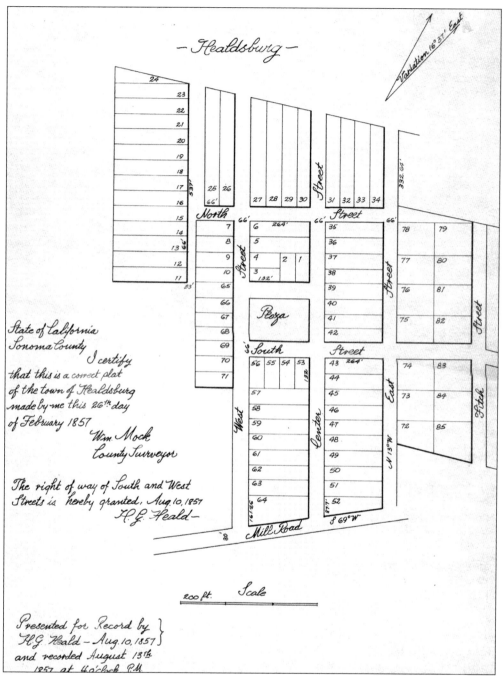

The surveyor's plat of the town Harmon Heald laid out around a central plaza was recorded by Sonoma County authorities in August 1857. The new owners of the Healdsburg lots began paying county taxes that year, according to 1857–1858 tax records. Early in the development, lots were said to be selling for $15, but real estate prices quickly escalated.

Three

BUILDERS OF OUR HERITAGE

In the early years, there were a few residences on the Plaza's boundary streets, but retail stores and professional services were predominant, including the office of colorful attorney Lewis A. Norton. He was elected president of the board of trustees in 1867, when the town incorporated. The most substantial building in the 19th century was Healdsburg's city hall, a handsome three-story brick edifice built diagonally across from the southeast corner of the Plaza in 1886, when the town had great municipal ambitions. Diagonally across the Plaza, the Union Hotel was a solid brick anchor on West Street (now Healdsburg Avenue). Beside it was the Rosenberg and Bush department store, founded in 1865 and operated by three-generations of the civic-minded Rosenberg family. The Young funeral service was another three-generation business.

The 20th century brought a wave of improvements. The first water main reached the center of town in 1900 through a system that boasted 42 fire hydrants. The energetic Ladies Improvement Club celebrated by donating a four-sided public drinking fountain. The automotive age arrived, but a hitching rail around the Plaza still accommodated farmer's wagons in the early decades. The Farmers and Mechanics Bank, founded in 1877, opened a new building on the northeast corner of the Plaza in 1908. The building still stands today.

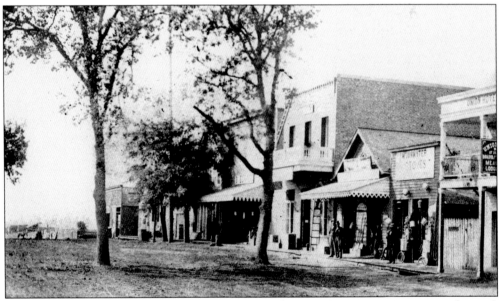

In 1859, trees grow in the main thoroughfare of the new town. A contemporary source observed, "The road through Healdsburg shows a fine disregard for traffic hazards such as trees in the street." This is a view looking south on West Street (now Healdsburg Avenue). The Union Hotel with a second-floor veranda is on the right, and the Plaza is out of view on the left.

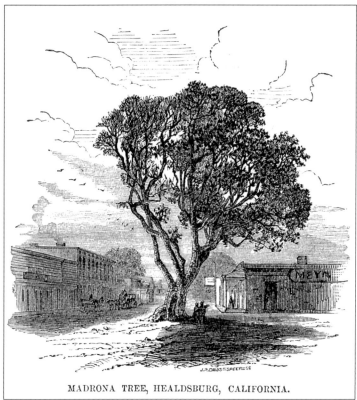

MADRONA TREE, HEALDSBURG, CALIFORNIA.

This madrone tree at the intersection of Powell Street (now Plaza Street) and West Street (now Healdsburg Avenue) on the northwest corner of the Plaza caught the eye of an English travel writer in the 1860s and was reproduced as a line engraving in his book on California experiences. At that time, the Plaza was lightly forested with original growth, including madrone and oak.

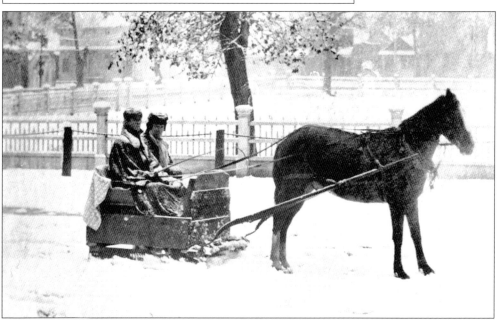

A rare snow fall of about 10 inches on Wednesday, December 3, 1873, brought this young couple to Center Street on the Plaza in a horse-drawn sleigh that looks to have been improvised from a buckboard seat. The *Russian River Flag* said, "The boys of the town were out in force and freely indulged in the pastime of snow-balling each other as well as passers-by."

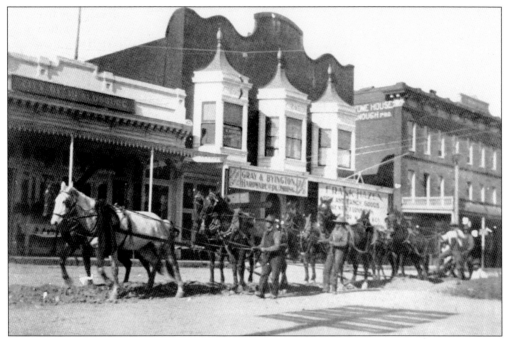

Horse teams and drivers dig a trench for the first water main down West Street (now Healdsburg Avenue) across from the Plaza in January 1900. Water from a newly constructed reservoir served more than eight miles of pipe and 42 fire hydrants. A sign marks the location of Gray and Byington hardware and plumbing, a new business to meet the needs of city water customers. It had been a grocery store a few months before.

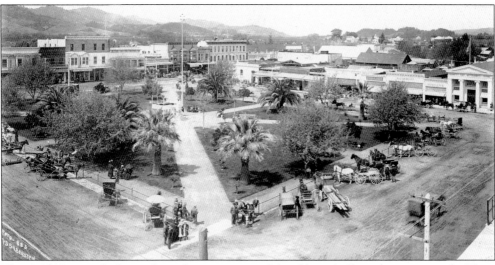

This c. 1907 image looks out from the upper story of the old city hall northwest across the Plaza. Horse-drawn vehicles dominate the scene, but a closer look discloses two automobiles parked at curbs on the north and west—a hint of things to come. The classic facade of the Farmers and Mechanics Bank on the right remains across from the Plaza's northeast corner.

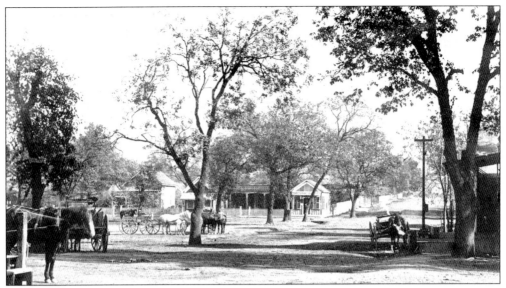

This 1867 view east toward what is now the intersection of Matheson and Center Streets shows the Plaza being used as a handy parking area for farm wagons in the early years of the town. The office of attorney Lewis A. Norton is marked by a sign on a corner of the intersection. In 1867, Norton was elected president of the first city board of trustees, which met in this office.

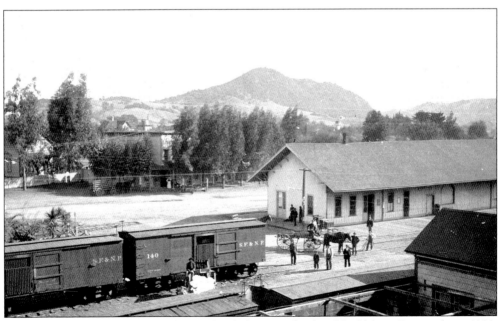

Freight cars waiting to be loaded, or unloaded, are at the first Healdsburg Depot about 1890. The Oak Lawn Hotel, located behind the trees, catered to railroad passengers. Fitch Mountain provides the backdrop for this local scene.

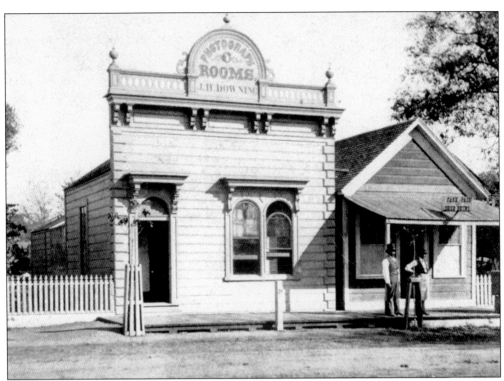

In the summer of 1871, Joseph Downing opened his "Photograph Rooms" on Center Street on the east side of the Plaza. His father was a Healdsburg furniture maker and undertaker who brought his family from Massachusetts via the Isthmus of Panama in 1857. Joseph Downing returned to the East in 1869 to study photography. He left town in 1879 to pursue his career, but settled again in Healdsburg late in life.

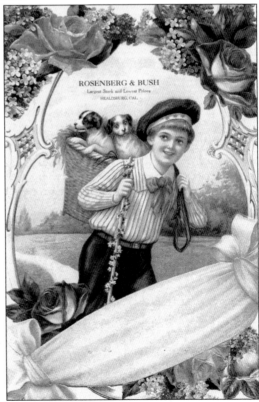

This c. 1921 advertising postcard for Healdsburg's Rosenberg and Bush department store evokes nostalgia for a simpler time with a floral-framed image of puppies and a boy in a sailor suit. The store, founded in 1865 by Wolfe Rosenberg, was the leading family-owned, dry-goods retailer in town for three generations. (Courtesy of Christine Coon.)

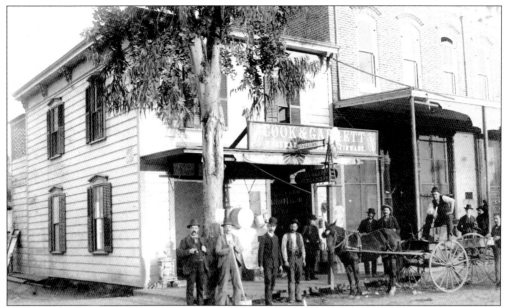

The Cook and Garrett Hardware store, c. 1890, was located on the 300 block of Center Street next to the Gobbi Building. The firm advertised "plumbing and tinning" and sold Cyclone windmills and Universal stoves. In 1892, the business moved into the Gobbi location. Garrett Hardware and Plumbing Company continues to do business in Healdsburg.

The patriotic bunting on the street sweeper's cart indicates a special occasion on the Plaza in the late 1890s. The view is east on Matheson Street toward a "Welcome" banner at the intersection of Center Street. Beyond is the extensive Matheson property where in July 1897, a cavalry troop of the National Guard, San Francisco, made camp after riding through town. The occasion would have called out the street sweeper.

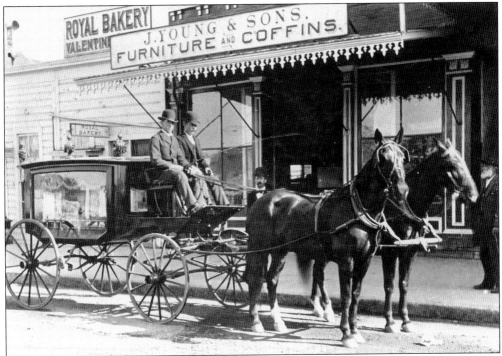

The Young funeral establishment became a three-generation business in Healdsburg. This mid-1890s photograph shows founder John Young (right) standing on the sidewalk with his son Thomas (center). Another son, Eben "Ted" Young, is seated on the hearse next to driver, Harry Cummings. Thomas' son Fred took over the business in 1919 after his father's death, changing the name to Fred Young and Company.

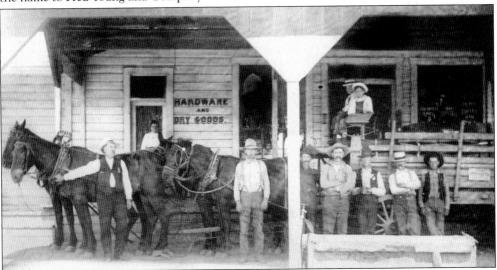

In 1909, proprietors and customers of the Dry Creek Store, located in the heart of Dry Creek Valley farmland, line up in the shaded wagon way for a picture. The owners, Mr. Boyce (left) and Mrs. Boyce (in the doorway), sold the business in 1917 to Lloyd and Lydia Goodyear, who operated it for many years. The store, established in 1881, remains in business today at the same location on Dry Creek Road.

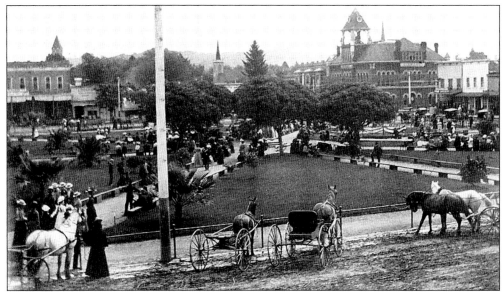

Town folk in their holiday finery assemble in the Plaza, *c.* 1906. The muddy street surface in the foreground was improved with pavement in the next decade. City hall, the brick structure commanding the southeast corner of the square on the right, was dedicated in 1886. It was torn down in the 1960s to make way for a more modest building. The traditional spire in the center of the photograph marks St. John's Catholic Church, now replaced with a modern church.

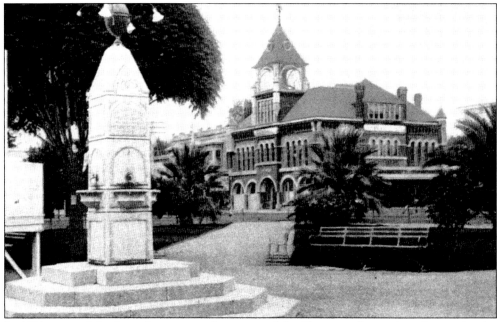

In 1901, a grand drinking fountain in the center of the Plaza was donated to the city by the Ladies Improvement Club. The ladies were given permission to tear down a popular bandstand to make way for the fountain. This caused controversy and petitions were circulated, but the club prevailed. Healdsburg's first city hall anchors this *c.* 1910 view to the southeast corner. Twenty-five years after its installation, the fountain was replaced by a flagpole. The benches pictured in the center are still in place today.

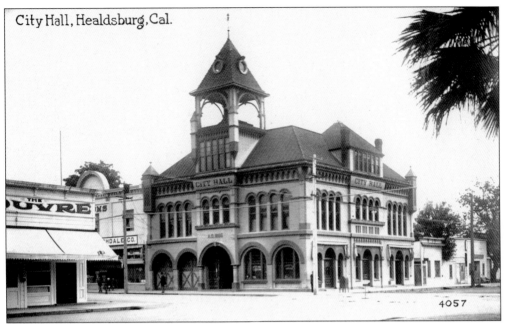

City Hall, Healdsburg, Cal.

4057

Healdsburg's first city hall was this three-story brick masterwork completed in 1886 for $12,500. It housed city offices and also provided space in the early years for the library, firemen's quarters, courts, and jail. After 74 years of service, it was deemed an "eyesore" by the *Healdsburg Tribune* and demolished in 1960. The location at the southeast corner of Center and Matheson Streets is now commercial property.

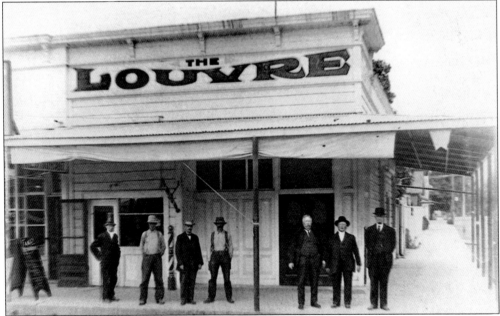

The Louvre restaurant—not to be confused with the Louvre Museum in Paris—operated at the northeast corner of Matheson and Center Streets, across from the City Hall, into the early decades of the 20th century. The group in front includes the businessmen and farmers who dined at the Louvre. The restaurant advertised "Quick and First Class Service" and "Plain Meals 25 cents."

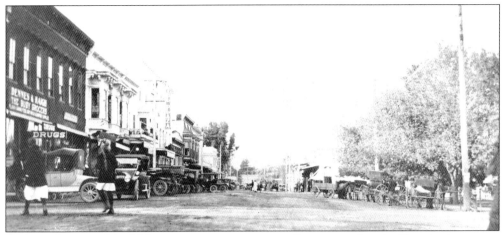

In the early years of the 20th century, as automotive traffic increased in the Plaza business area, there was an attempt to accommodate farmers and others who still relied on the horse. Wagons and carriages could be tied to the hitching rail around the Plaza. The view looking north on West Street (now Healdsburg Avenue) shows parked cars using the surrounding curbs.

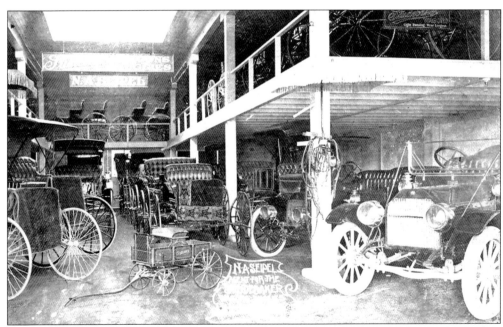

The Healdsburg salesroom of Studebaker dealer N. A. Seipel illustrates a transitional period in the transportation industry in the second decade of the 20th century. Motor cars share space with wagons and carriages on the main floor. The gallery is devoted to horse-powered vehicles. In the foreground is a child's wagon.

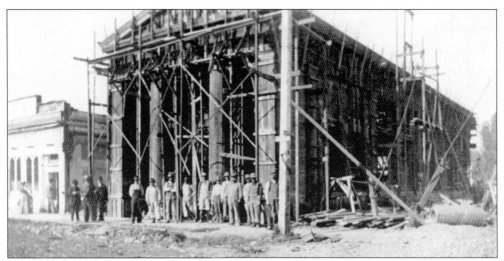

In 1908, the Farmers and Mechanics Bank, located at the northwest corner of Powell (now Plaza) and Center Streets, was under construction. George Day, standing fourth from left, was contractor for the building. This was the second bank building in Healdsburg—and the first bank in the county to use a time lock on its safe. *The Russian River Flag* noted that the "counting room is commodious." This handsome building is still standing today.

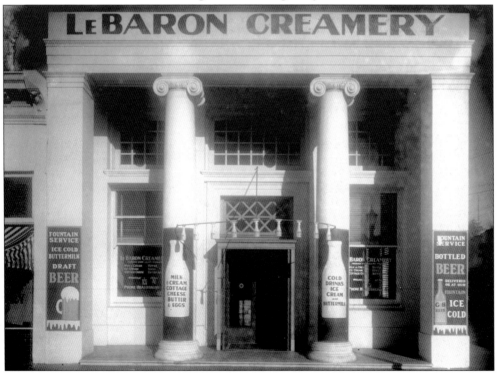

An arch of milk bottles hangs over the entrance to H. C. LeBaron's creamery, established in 1932 in the old Farmers and Mechanics Bank building on the Plaza at Powell (now Plaza) and Center Streets. The plant bottled milk and cream and produced ice cream, butter, and cheese. The creamery offered soda fountain service on site and, as the odd mix of advertising makes clear, sold both draft and bottled beer.

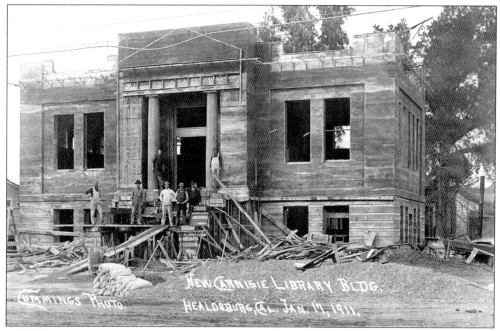

In 1911, the Carnegie Library is shown here near completion of construction. It was made possible by a $10,000 grant from industrialist Andrew Carnegie. The town provided the site on Matheson Street at Fitch Street. The library, previously housed in quarters at city hall, expanded into this neoclassical revival building designed by prominent Petaluma architect Brainerd Jones.

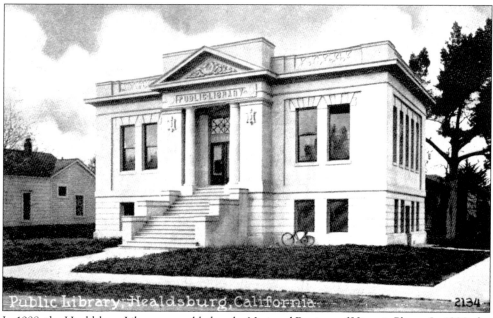

In 1988, the Healdsburg Library was added to the National Register of Historic Places. In 1990, the building was renovated to become the home of the Healdsburg Museum and Historical Society.

Four

INTENT ON LEARNING

Education was important to the early settlers. The Russian River Institute, a private school, was organized and built in 1857, the same year Healdsburg was founded. University Street was named in its honor. The first public elementary school was built in 1871 on Tucker Street. The school soon expanded and, by 1880, had 227 students. Public high school instruction was first offered in 1888, and in 1891, the school graduated nine scholars (eight girls and one boy) before a crowd of 600 proud townspeople.

The Seventh-day Adventist Church operated the Healdsburg College at Fitch and Powell Streets (now Plaza Court) from 1882 to about 1906, offering a variety of academic and vocational courses. In 1906, the public school trustees built a two-story, 11-room grammar school on the original Tucker Street site. The main stone building was torn down in 1934 because of concerns over earthquake safety. A mission-style school replaced it at North and First Streets. In 1954, a new high school building was constructed at Powell Avenue and Prince Street.

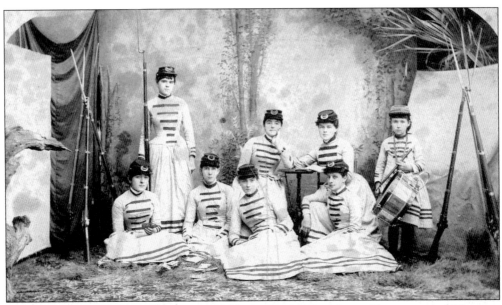

The Healdsburg Albanian Literary and Military Society was formed by a group of 25 young ladies who met weekly in the 1880s to discuss authors and musicians. In addition, to the delight of Healdsburg citizens, they performed marching drills in their red, white, and blue uniforms. Members pictured here, from left to right, are (first row) Minnie Reynolds McMullin, Emma Truitt Petray, May Shaw, and Artie Griest; (second row) Emma Logan Beeson, Millie Emerson Phillips, and Sara Sullivan Ross. The little drummer girl is not identified.

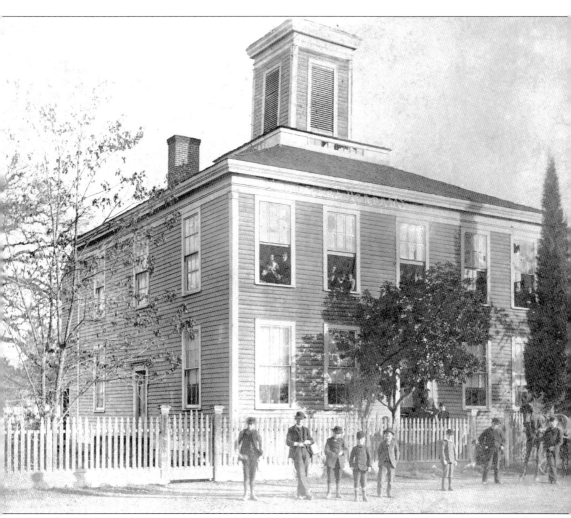

The Russian River Institute was built in 1857, the year Healdsburg was founded, on a site that became University Street between Tucker and Haydon Streets. It was the town's first private school. This *c.* 1875 photograph shows faculty and students in the school's open windows on the second floor, while uncomfortable boys in formal attire are in front of the trim picket fence.

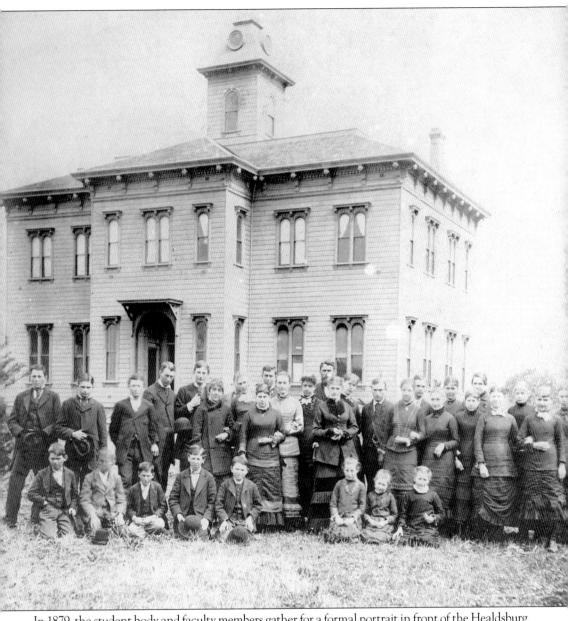

In 1879, the student body and faculty members gather for a formal portrait in front of the Healdsburg Institute. Illustrating the town's early emphasis on higher education, the building was constructed in 1877 in the area around Plaza Court off Fitch Street. Prof. Heber Thomson was principal. The institute merged with the Alexander Academy in 1880 to become the Healdsburg Academy.

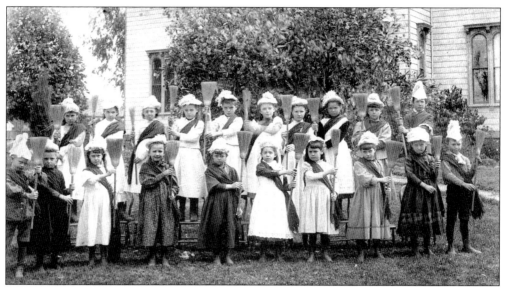

The third-grade class at Healdsburg College, c. 1890, shows off their handmade brooms created as part of a practical curriculum that offered more than academic studies. Boys and girls were instructed in shoemaking, tent making, blacksmithing, tailoring, and dressmaking. Boys also helped care for farm animals and girls had domestic duties. The Seventh-day Adventist Church, which ran the college, left Healdsburg in 1908 and reopened in Napa County as Pacific Union College.

In 1882, the Healdsburg College was founded by the Seventh-day Adventists at Fitch and Powell (now Plaza) Streets and had annual enrollments as high as 200 students during its more than 20 years of operation. The institution, renamed the Pacific Union College, relocated to Angwin in Napa County, where it remains today.

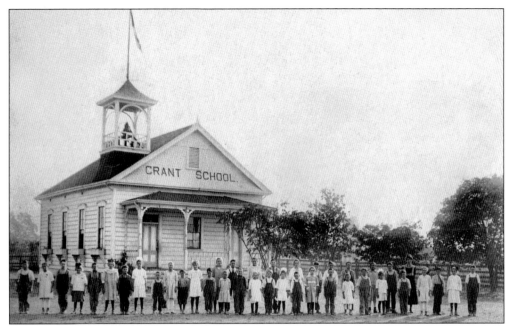

Students of Grant School on Old Redwood Highway assemble for a *c.* 1915 picture with their teacher, right. The 39 children of various ages on display here demonstrate the demands on lone teachers of grades one through eight. The school was named for the family of John Delano Grant, a prominent rancher. The building later converted to a private residence. (Courtesy of Louis J. Foppiano.)

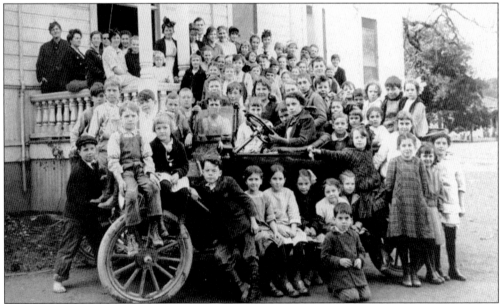

This group of students, with their teacher at the wheel, poses in front of the Geyserville Grammar School in 1914. Before 1915, Geyserville teenagers had to commute to Healdsburg to attend high school. By 1936, the one-room grammar schools of the Lincoln, Hamilton, Canyon, Oriental, and Independence School Districts were consolidated into the Geyserville School District. In 1943, Peña School was added. (Courtesy of the Sonoma County Library.)

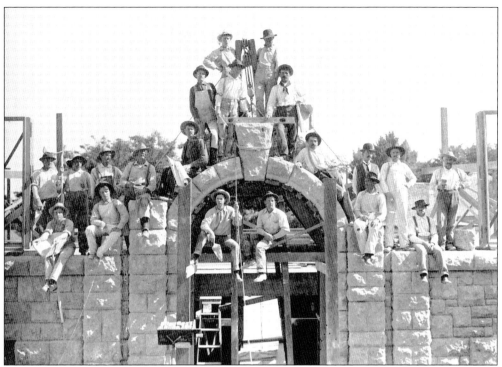

The keystone is set in the entrance arch of the Healdsburg Grammar School during construction in 1906. The building crew, many of them skilled stone workers who emigrated from Italy, gathers around for the event. In 1934, this main building of the grammar school was declared an earthquake hazard and torn down.

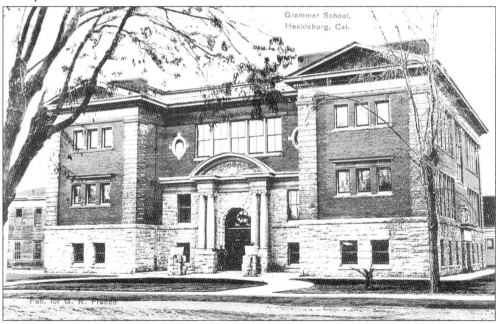

The 11-room Healdsburg Grammar School, completed in 1906, was financed by a bond issue of $35,000, approved by the voters in May 1905. It replaced an elementary school built in 1871.

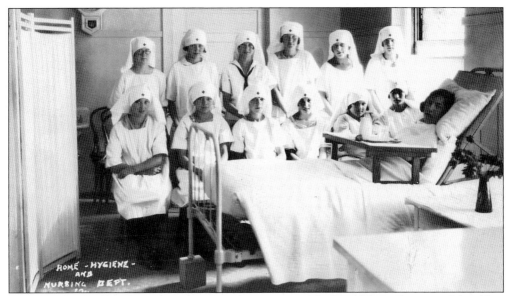

The home room of the hygiene and nursing department of the Healdsburg Grammar School has been transformed into a demonstration hospital facility in this 1924 photograph. Girls were urged to consider nursing as a career—12 of them are seen here wearing professional-looking caps and uniforms. A meal has been served the "patient."

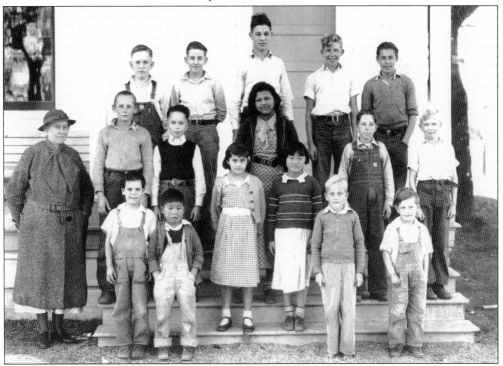

On a February day in 1936, the student body of Mill Creek School assembled for the photographer. The teacher, Mrs. Clara Schieffer on the left, taught grades one through eight as was the custom of small rural schools of the time. The community of Mill Creek, west of Healdsburg, grew up around the first mill established in the region in the early 1850s.

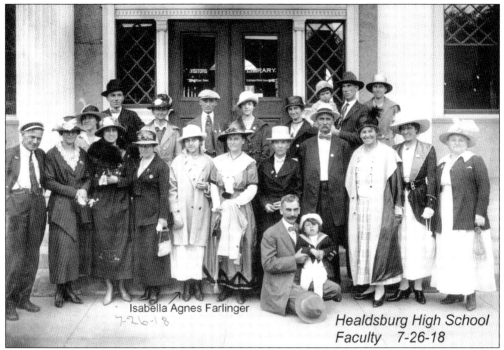

Isabella Agnes Farlinger

7-26-18

Healdsburg High School
Faculty 7-26-18

In July 1918, the faculty of Healdsburg High School forms up at the entrance of the new school building during ceremonies celebrating its construction. Among them were teachers whose subjects included Latin and ancient history, Spanish and music, and science and athletics. The *Healdsburg Tribune* proudly reported every classroom had a telephone connection to the principal's office. The enrollment was 172.

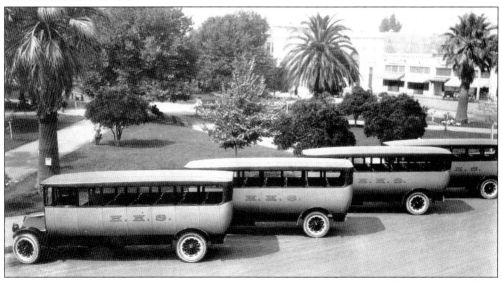

Four new buses of the Healdsburg High School were lined up to be admired on the east side of the Plaza at the start of the fall term, September 1922. "They are finished in battleship gray with black trimmings and have the letters 'H. H .S.' in gold on both sides," the *Healdsburg Tribune* reported. The buses had upholstered seats for 30 passengers. It was "palatial" service for students from rural districts, the paper said.

Salvation Army Capt. Wilfred C. Bourne, left, was the first superintendent of the Lytton Springs Orphanage from 1904 to 1916. In the early years, the orphanage accepted very young children. The age for admission was later changed to between six and 15 years. Here a little new arrival is matched up with a garment by one of the women on staff.

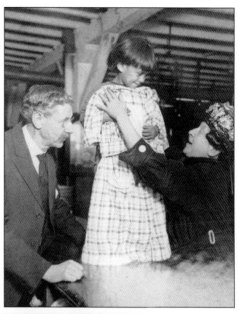

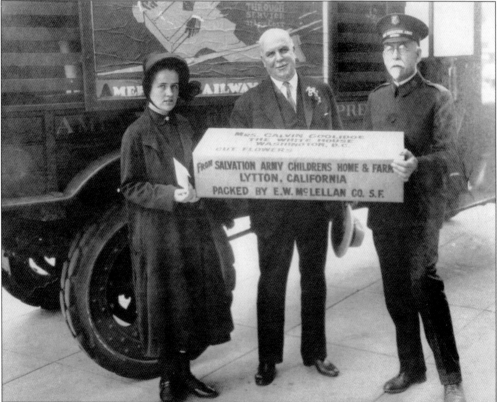

The gentleman in the middle is San Francisco's Mayor James "Sunny Jim" Rolph, wearing his trademark boutonniere. The occasion is the dispatch of what appears to be a gift flower box to the wife of Pres. Calvin Coolidge, c. 1926. On the right is Lt. Col. Wilfred C. Bourne of the Salvation Army's Lytton Orphanage, north of Healdsburg.

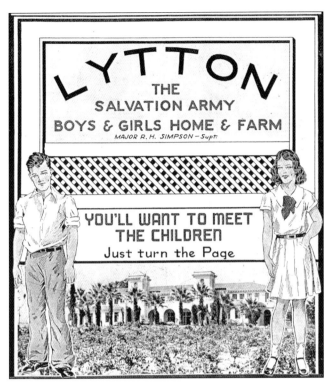

LYTTON

THE SALVATION ARMY BOYS & GIRLS HOME & FARM

MAJOR R. H. SIMPSON – Supt.

YOU'LL WANT TO MEET THE CHILDREN

Just turn the Page

This booklet, published by the Salvation Army in December 1937, said there were 220 boys and girls living in the Lytton home at the time. The broken homes of the Depression added to the population. "They are victims of unhappy circumstances over which they had no control." The superintendent, Major R. H. Simpson, and his wife had a staff of 33 to care for their charges.

It was the practice of Healdsburg newspapers in the early years of the 20th century to log the admission of children to the Lytton home. The *Healdsburg Enterprise* printed this account in January 20, 1912. A half orphan was a child with one surviving parent. During its 54 years of service, the home for boys and girls cared for some 11,000 children.

ORPHAN CHILDREN

The following orphans and half-orphans have been received at the Golden Gate Orphanage at Lytton from Oct. 1st., to Jan. 6th., 1912.

HALF ORPHANS

Clarence Hanson	9 years
Anna Hanson	6 years
Pete Corel'l	4 years
Russel Badger	8 eyars
Dora Barboez	2 years
Amelia Barboez	3 mos.
Berna Baker	4 years
Alfred Baker	6 years
John Spellacy	10 years
Arthur Spellacy	8 years
Earl Russell	10 years
Ray Smith	6 years

ORPHANS

Chester Boyce	9 years
John Hanoran	9 years

C. W. BOURNE, Major.

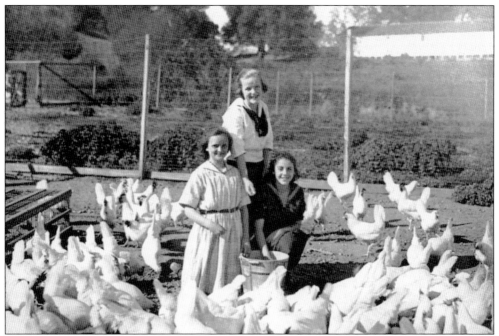

The children of the Salvation Army Boys and Girls Home and Farm helped out with chores as part of a training program to equip them for work in the outside world. Here girls scatter feed to some of the 2000 White Leghorn and New Hampshire chickens on the farm in the 1930s. Fresh eggs from the chickens were an important part of the diet at the home.

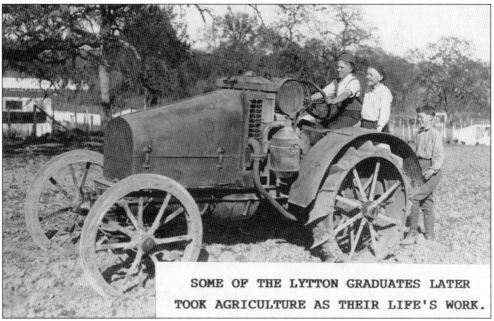

SOME OF THE LYTTON GRADUATES LATER TOOK AGRICULTURE AS THEIR LIFE'S WORK.

Boys are at play aboard this tractor, but agricultural training was a serious pursuit as the Lytton Springs Orphanage evolved into the Salvation Army Boys and Girls Home and Farm in the early decades of the 20th century. By the 1930s, the home operated a farm of 800 acres, including orchards, vegetable gardens, and prize-winning livestock. Boys on barn duty got up at 5:00 a.m.

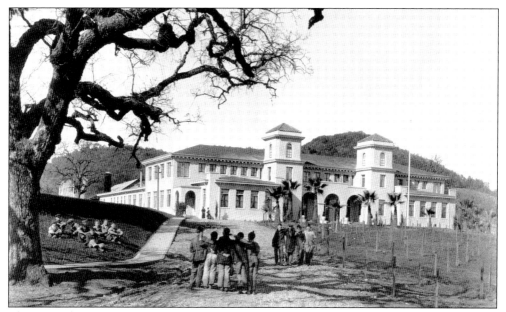

This new administration building for the Salvation Army Boys and Girls Home and Farm at Lytton Springs, north of Healdsburg, was dedicated in January 1921. In 1920, the old resort hotel that the Salvation Army took over when it founded the orphanage in 1904, burned down. The new building held offices, a dining room, a kitchen, and a dormitory for girls. The boys, some of whom are shown here, lived in cottages on the grounds.

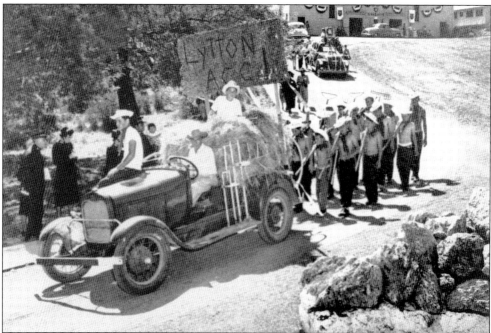

A vintage car and a contingent of boys with farming tools on their shoulders start out from the grounds of the Salvation Army's Lytton Springs home for a Future Farmers Parade in Healdsburg, c. 1950. Teenagers from the home attended Healdsburg High School and the town made sure the youngsters were part of community events. The facility closed in 1958 after 54 years of operation.

Five

JOYFUL PURSUITS

In 1847, an American bear hunter discovered a wild canyon in Northern California where steam spewed from vents in the earth and the air reeked with the smell of sulphur. This amazing place became known as The Geysers, although technically the steam was produced from fumaroles. In Victorian society, The Geysers were more than a natural wonder. They allowed visitors to pursue an alleged therapeutic regime of mineral water and hot spring baths. Healdsburg was a staging point for visitors prepared to take the five-hour journey north over perilous roads.

The Russian River offered abundant fish for the angler and it was a boater's idyllic dream early in the 20th century. Others embraced the automobile and aviation ages. In the middle of the century, the river between the bridges became the arena where more enthusiastic water sports were pursued, including a novelty—women's wine barrel racing. The community vigorously promoted the summer resorts developed on the river beside Fitch Mountain. Locals played closer to home at Merryland Beach, now Memorial Beach, and dined at the Ark Restaurant on the river's bank.

In 1926, Madeline Moore, Faith Powell, and Paloma Grant appear to be cooking lunch on a steam vent in this publicity shot at The Geysers.

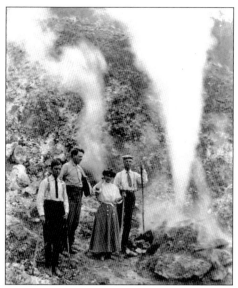

Tourists hike carefully through The Geysers canyon, getting close to the spewing fumaroles. The loud noise of escaping steam and the pungent sulphur odor did not deter visitors to one of California's most popular natural wonders in the late 19th century. Bear hunter Bill Elliott discovered the canyon in 1847.

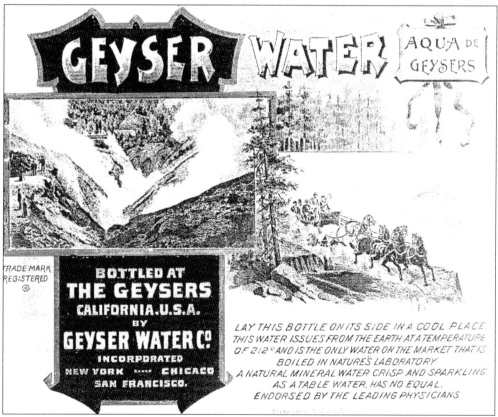

One of the appeals of The Geysers to 19th century visitors staying at The Geysers Hotel was the supposed therapeutic value of drinking mineral water from hot springs and soaking in warm water baths. American enterprise saw the commercial advantage of bottling the mineral water at the source and bringing it to consumers around the country. The copy for this c. 1880 bottled water advertisement has a familiar ring.

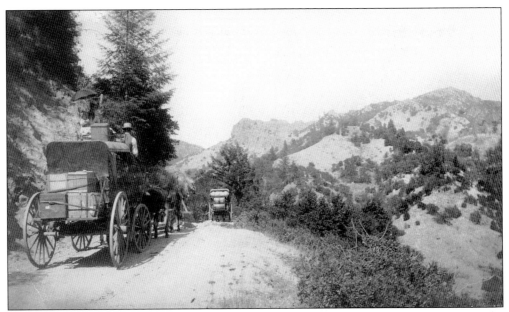

In 1881, a stage loaded down with luggage and freight on the rear platform and roof takes the Calistoga and Lakeport Road up Mount St. Helena to neighboring Lake County. The driver is Joe Johns. It is summer and the California panorama of tawny hills rolls out before the road.

Stages pulled by six-horse teams conveyed tourists, many of them distinguished visitors from the East, to The Geysers over a rough road with steep falloffs on either side. Driver Clark Foss's daredevil style at the reins made him a local legend. A September 1869 edition of the *Russian River Flag* described a hair-raising trip with Foss, concluding that his eight-year, accident-free record assured riders of "comparative safety."

Renowned stagecoach driver Clark Foss originated and drove the passenger lines along a mountainous route from Healdsburg to The Geysers, and later from Calistoga to the world-famous hot springs during the 1850s and 1860s. The six-foot, two-inch, 220-pound Foss was considered by a contemporary writer "not only an unequaled driver, but a man of genius and a philosopher."

In 1875, Bostwick and Emerson, proprietors of the Geyser Livery and Stage Stable, ran daily stages to the Geyser Springs, a popular Victorian resort. The route went northeast through the quicksilver mining area of Pine Flat and Mercuryville and along the vertiginous Hogsback Ridge. The stages left at 6:00 a.m. and returned at 6:00 p.m. The firm also rented saddle horses and turnouts (horse-drawn carriages).

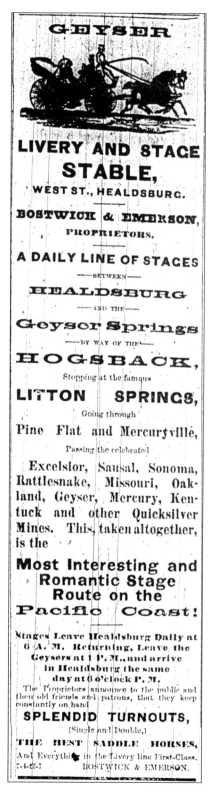

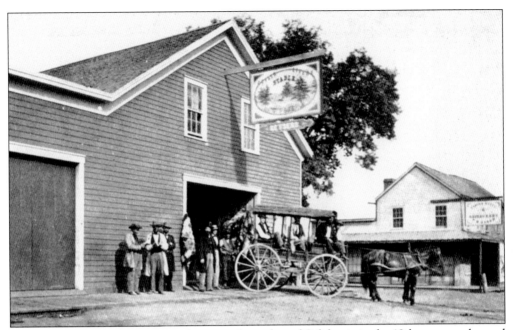

The Geysers, one of the most popular natural wonders of California in the 19th century, elevated Healdsburg from the status of remote farm town to important staging point for out-of-state visitors. Here, c. 1860s–1870s, the typical California stage, with canvas sides rolled up, gets ready to roll. Calistoga in Napa County to the east offered a competing service. Stages continued to make the run into the 20th century. (Courtesy of the Society of California Pioneers, San Francisco.)

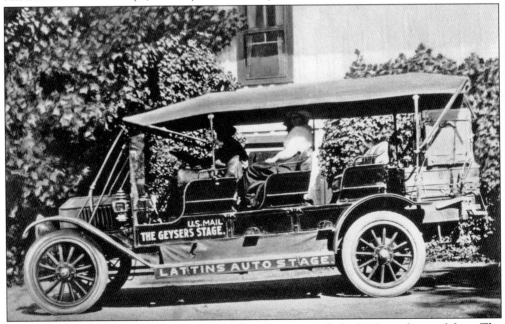

By 1916, Ray Lattin's Auto Stage transported both guests and the U. S. mail to and from The Geysers. Foss's horses no longer made the hair-raising trip up the hills. Lattin's Stanley Steamer gave a more sedate ride, even though he had to stop and back up to make it around some of the turns and it was common to stop and draw water for the engine from a creek.

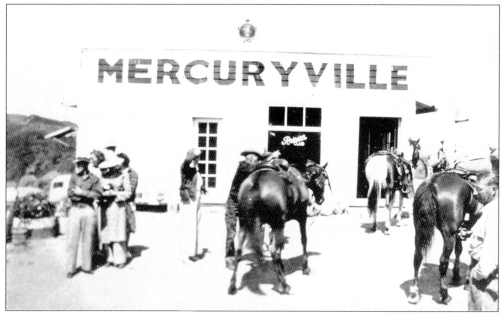

A party of horseback riders mounts up on the site of the abandoned mining community of Mercuryville, c. the 1920s. Founded in 1874, Mercuryville was one of a number of hasty settlements that flourished and faded in the quicksilver mining district northwest of Healdsburg. The building here served as a gasoline station and refreshment stand on the road to The Geysers.

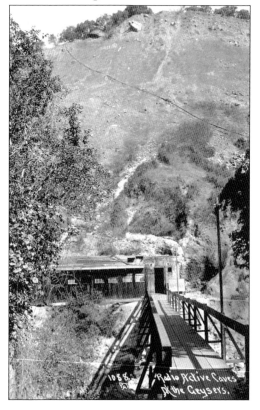

This foot bridge across The Geysers canyon led to three caves carved into the hillside. These sweat caves were used by the indigenous people long before the tourist rush of the 19th century. The natural steam heated the caves in temperatures from hot, to hotter, to hottest. Visitors sat on benches, sweated away their troubles, and re-crossed the bridge to cool in a mineral water pool.

The Geysers Hotel, built about 1868, replaced the canvas tents and cabins that accommodated early visitors. Hunting in the rough terrain surrounding the resort was a popular pursuit. Here a hunting party relaxes in the shade of the oak tree. Their kill, which appears to be a boar, hangs from the tree. (Courtesy of the Society of California Pioneers, San Francisco.)

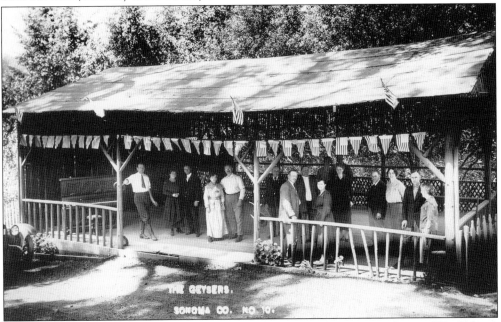

In 1915, holiday bunting drapes an open-air dance hall at The Geysers, northeast of Healdsburg. The hall was an apparent attempt to broaden the social attraction of the former fashionable health spa as other, more convenient resorts were developed along the Russian River. In the 1930s, the old hotel at The Geysers burned down.

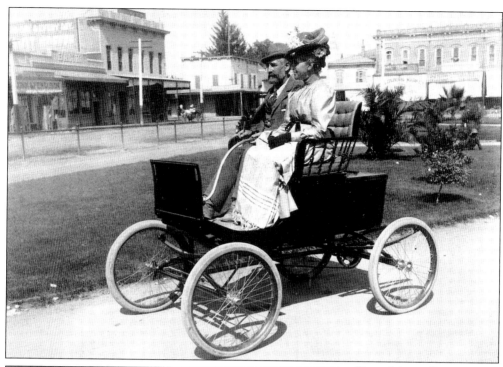

One of the earliest automobiles in town, the 1902 Locomobile with tiller steering, rolls through the Plaza with W. T. Albertson, a lumber mill owner, and his wife aboard in proper driving attire. There was a 14-inch boiler beneath the seat which provided the steam for the twin-cylinder engine. Much of the running gear consisted of bicycle parts.

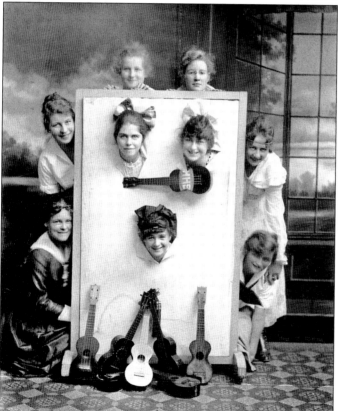

These young ladies display the high spirits that made them a popular, ukulele-playing, rooting section for the Healdsburg High School's athletic teams. The ukulele club was formed in 1916, and also performed away from the sports field at recitals featuring "old plantation songs and popular Hawaiian airs."

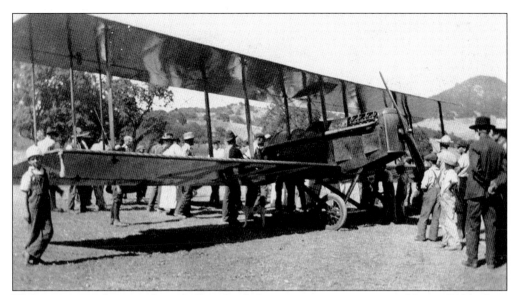

With airports in short supply, early flyers landed on any convenient pasture. Here a 1918 biplane is the center of attention and was the first airplane to give rides to many locals at the big hop-and-prune ranch of Clarence Hall, located near Healdsburg in the Alexander Valley. The first local airport was the short-lived Athey Field, established in 1941 on a site now occupied by the Healdsburg Hospital.

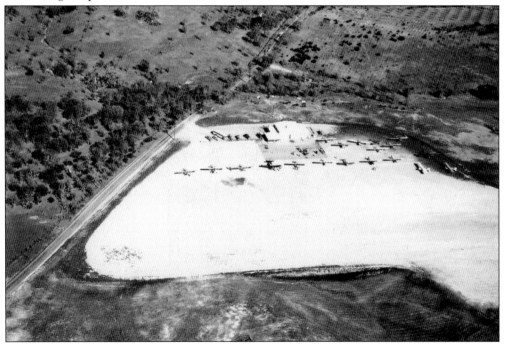

At the end of World War II, a graded landing strip for airplanes was established on the ranch of brothers Lewis and Edward Norton, fronting the Lytton Springs Road northwest of Healdsburg. Known as the Norton Sky Ranch, it provided popular flight training for returning veterans and students of the Healdsburg High School aviation science class. The dirt strip and hangar facilities were leased to the city in 1962 to become the Healdsburg Municipal Airport.

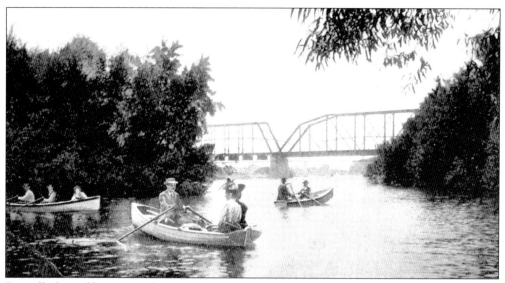

Formally dressed boaters on the Russian River at Healdsburg create an idyllic scene that appeared on postcards, *c.* 1910. The boaters are upstream from the rail and road bridges crossing the river on Healdsburg's east side.

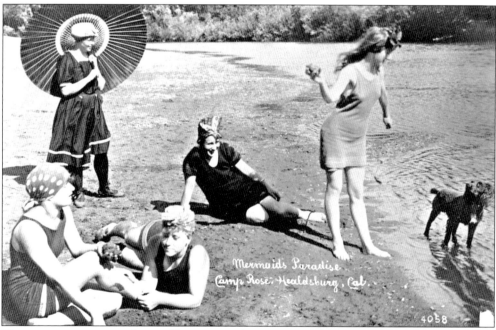

These young women—a bevy of beauties in the promotional lexicon of the time—gather for publicity purposes on the beach of the Russian River's Camp Rose, a popular summer resort beside Fitch Mountain. The reason for the eclectic display of bathing costumes in this *c.* 1920s postcard is lost in time. The black dog waits to plunge into action after the ball.

These young women in fashionable bathing suits hoist a canoe on the bank of the Russian River to demonstrate the recreational possibilities of the Healdsburg area. In this c. 1940 picture are Vivian Micheletti, Alta Badger, Faye Auradou, Eva Rafanelli, Rubye Gambetta, and Adeline Passarino, all residents of Healdsburg.

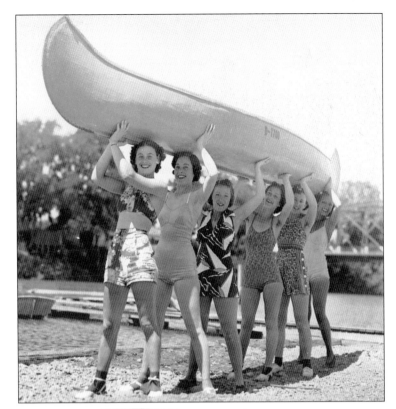

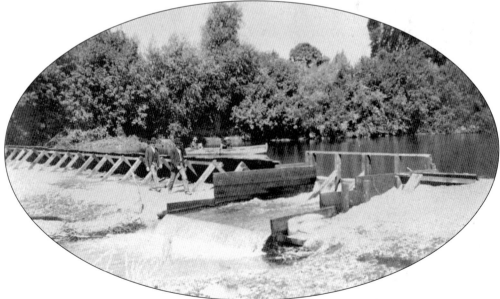

The summer dam on the Russian River, below the railroad and vehicle bridges, was a recreational tradition established around the turn of the 20th century. The body of water created was called Lake Sotoyome—recalling the name of the original land grant where the town was founded. In this image, two men stroll downstream of the dam toward the spillway while fishermen row on the lake.

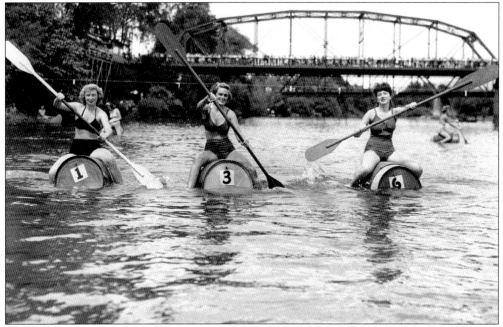

One of the final events of the three-day Harvest Festival at the end of August in 1946 was the women's wine barrel race on the Russian River under the highway and railroad bridges behind the summer dam. The participants here, from left to right, are Virginia Patterson, Harriet Carroll, and Barbara Kron. The *Healdsburg Tribune* said the competitors "spent the better part of the week practicing with the tricky drums."

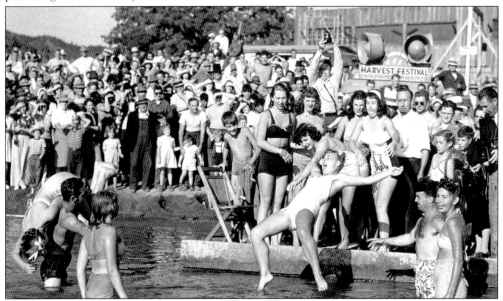

The winner of a wine barrel race in the Russian River, believed to be Lillian Page, gets a victory dunking during the 1946 Harvest Festival with the help of Billie Jo Bennett Haley, one of the finalists. Other participants included Lenora Lewis and Diane Wolking standing to the left behind Haley. Local wine businessman Joe Vercelli, in white shirt sleeves on the right, was one of the race's sponsors. (Courtesy of the Sonoma County Library.)

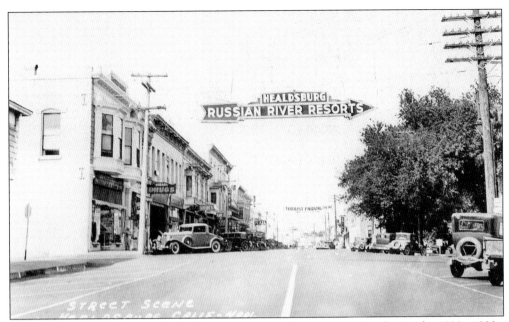

The Russian River resorts on Fitch Mountain attracted so many tourists during the 1920s, 1930s, and 1940s, that an electric sign was installed at the intersection of West (now Healdsburg Avenue) and Matheson Streets to help direct traffic. Some families from the San Francisco Bay Area returned to the same summer cottage, rental cabin, or campground every year and made lasting friendships and ties to Healdsburg.

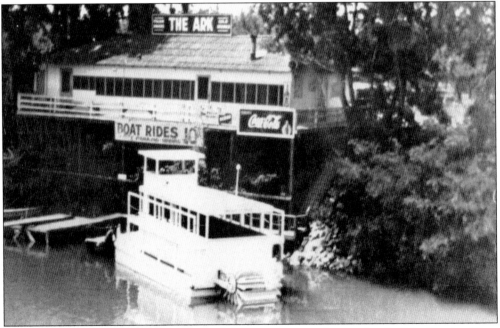

When this picture was taken in 1936, the Ark Restaurant, on the west bank of the Russian River below the highway bridge, was a culinary institution in Healdsburg. Proprietors Julio and Gino Sbragia served "delicious Italian food" and fresh fish from the river. The little paddle wheeler could take passengers across to Merryland (now Memorial) Beach.

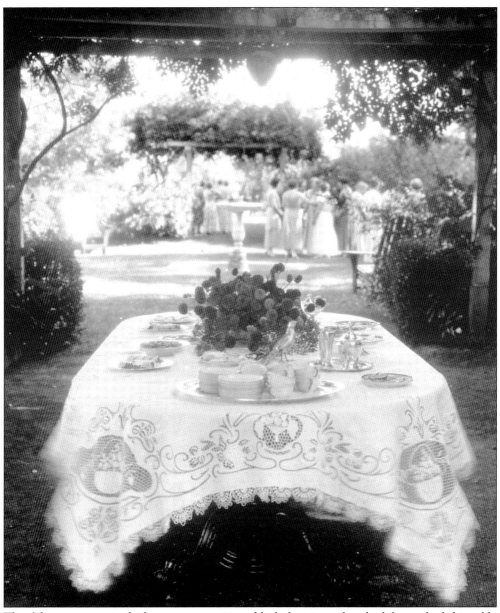

The elaborate tea service laid out on an exquisite tablecloth waits under a leafy bower for fashionably gowned ladies on the lawn of the Snook residence. The tea party was given in July 1932 by Nettie Cole Snook and her two daughters, Marguerite and Cleone, for Mrs. Snook's niece, Mrs. Ruth Lucas Gilliland of Dallas, Texas.

Six

CHURCHGOING FOLK

The churches that gave the town of Healdsburg its spiritual character began going up the year of its founding in 1857. Among the first was the Methodist Episcopal North Church, located on a lot on the south side of the Plaza. The Methodist Episcopal South Church was built on East Street nearby. Prior to the Civil War, the M. E. church was so divided on the subject of slavery that congregations across the U.S. split into "north" and "south" factions. The Methodists of the "Plaza Church," as it was known, sold their property to the Presbyterians in 1861 and constructed a new church at Fitch and Haydon Streets in 1870. The first elder of the Presbyterian church was pioneer Cyrus Alexander. In 1933, the Methodists and Presbyterians joined to become the Federated Church of Healdsburg. The First Baptist Church, originally given land on the town's south side by Harmon Heald in 1858, built a church in 1868 on a lot on Fitch Street it still occupies. In 1908, the church was remodeled to its present form.

The Seventh-day Adventists established a modest church on North Street in 1871, and later founded a private high school. In 1886, the Adventists constructed one of the town's largest churches at Matheson and Fitch Streets. It was demolished in 1921. Catholics purchased land southeast of Matheson and East Streets in 1873 and in 1910 dedicated a new, two-spired church, St. John the Baptist, which served the growing parish for decades. A guild hall, built for St. Paul's Episcopal Church members in 1888, was moved to a site at Matheson and East Streets in 1900. It was remodeled into a place of worship and has undergone several alterations since. In 1900, the Church of Christ, one of the first organized religions in Healdsburg, built a new church at East and Powell (now Plaza) Streets. It is there today.

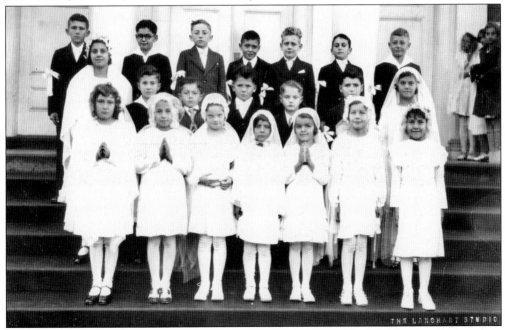

Healdsburg photographer S. E. Langhart photographed this group of children in 1924 in their first communion finery in front of the (second) St. John's Catholic Church.

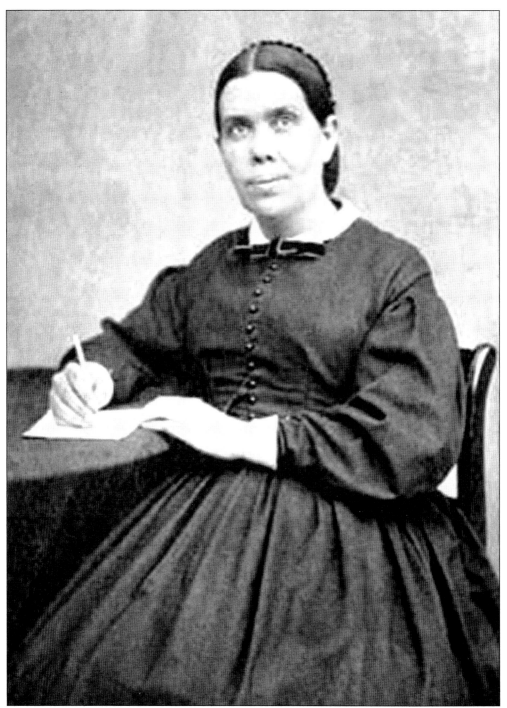

Ellen G. White, founder and prophetess of the Seventh-day Adventist church, penned some of her most influential religious writings while living in Healdsburg in the 1870s. She and her husband, James, moved from West Dry Creek Road to Powell Avenue to be closer to Healdsburg College, the Adventist institution that opened on Fitch Street in 1882. (Courtesy of Elmshaven Historic Site.)

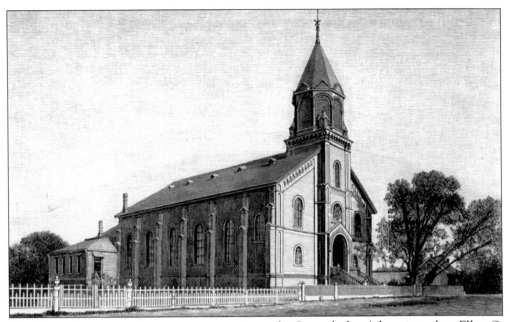

Healdsburg became an important community to the Seventh-day Adventists when Ellen G. White, one of the religion's spiritual leaders in the mid-19th century, took up residence in the town. She was influential in the founding of the Adventists' Healdsburg College in 1882. This image of the Seventh-day Adventist Church, built in 1884 at Fitch and Matheson Streets, is from a college catalog.

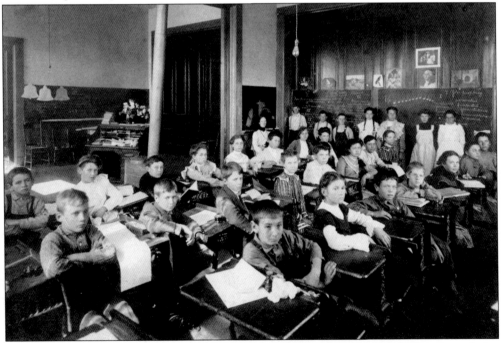

Shown here is a 1904 Sunday school class at the Seventh-day Adventist church. The Seventh-day Adventists attracted one of the largest congregations in town at the turn of the century, and built a substantial Gothic Revival church at the corner of Fitch and Matheson streets.

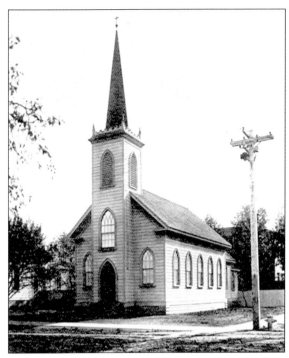

The first Mass was said in Healdsburg in 1860, and the first Catholic church (left) was built in 1873. A new St. John the Baptist Catholic Church (below) was built in 1910 with double spires in a Romanesque style to serve a growing congregation. In 1964, for the same reason, this building gave way to a modern structure on the old location at the southeast corner of Matheson and East Streets.

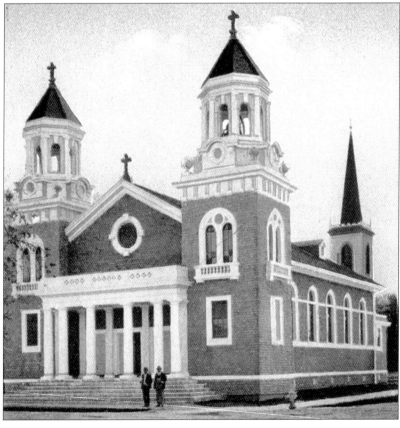

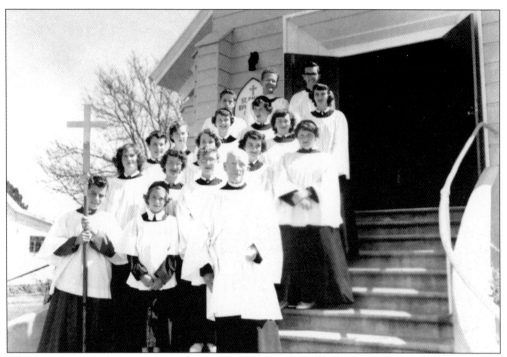

After singing a full choral service on Easter Sunday 1954, the St. Paul's Episcopal Church choir gathered on the church steps. Standing with the choir is Rev. Frank B. Kent, then St. Paul's minister.

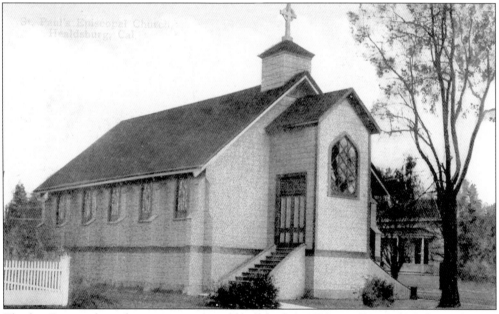

The first Episcopal parish structure was a guild hall, built in 1888 near East and Matheson Streets. In 1900, it was moved to the northeast corner of the intersection. The building was remodeled for worship and St. Paul's Episcopal Church was consecrated in 1913. The church, as seen in this early 1900s picture, has since undergone other architectural changes. The original pews, handmade in 1902, are still in use.

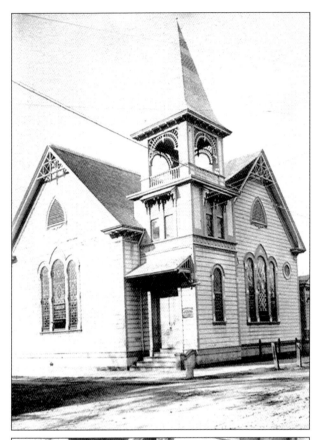

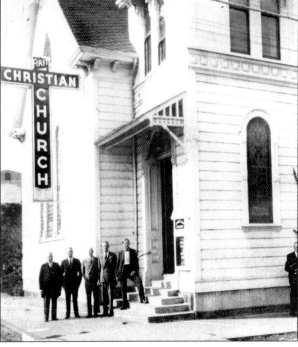

The Christian Church was organized by Elder F. M. Marion in 1857, the same year that Healdsburg was founded. From an original membership of 10, the congregation grew tremendously during the 1880s. In 1892, Santa Rosa contractors Simpson and Roberts built the existing Gothic Revival church. In 1917, some members of the Christian Church joined individuals from the Baptist church to form a new congregation. Since then, the house of worship has been the First Christian Church and is currently known as the Christian Bible Church.

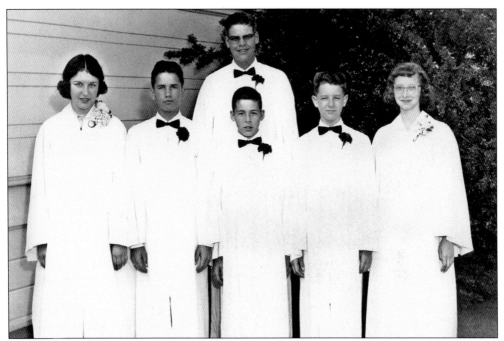

In 1957, this group of young people was confirmed by Rev. Richard Wagner at Good Shepherd Lutheran Church. Pictured here are (first row) Jeanette Jones, Gary Dickson, Martin Johnson, Steve Solem, and Carol Isaacson; (second row) Paul Lewering.

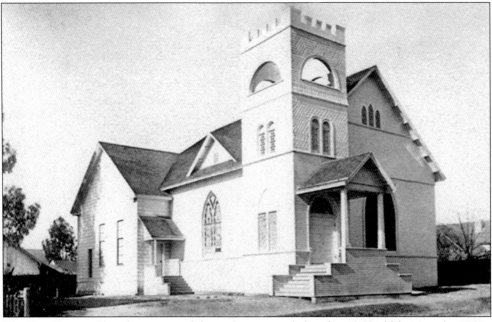

The First Baptist Church was one of the early organized churches in Healdsburg in the 1850s. After meeting at various homes and schools, members built the First Baptist Church on Fitch Street in 1871. In 1908, the original building was moved to the rear of the lot and the present church erected. A distinguishing feature is the central stained glass window depicting "Christ, the Good Shepherd."

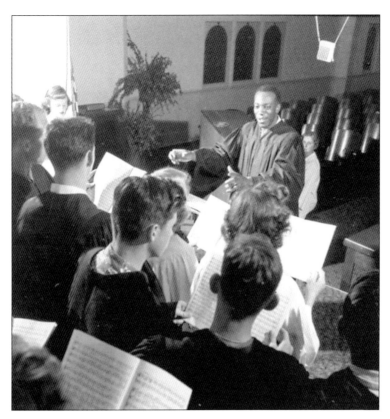

The popular chancel choir of the Federated Church sang in Healdsburg, and also performed in churches in the Bay Area. *Ebony* magazine published a 1951 feature about Smith Robinson, the choir director pictured here, leading the group in song. (Courtesy of Marion Hoy Jones.)

In the early 1950s, Smith Robinson, seated second from the right in the front row, took his youth choir of Healdsburg's Federated Church on appearances around the Bay Area. Here they join the Baptist choir of his brother-in-law's church in San Francisco.

Seven

CHAMPIONS AMONG US

The earliest residents of Healdsburg found time for and pursued with passion the goals and standards of athletics and organized team competition. Of particular interest and achievement were the pursuits of track and field and the national pastime of baseball. Many successful and talented local athletes went on to distinguish themselves in the wider world of professional and Olympic sport.

Ralph Rose won a total of six medals at three Olympic games. The six-foot, five-inch, 250 pound Rose was the only man to win national championships in shot put, discus, and javelin, and the first to put the shot more than 50 feet. Track and field Hall of Famer Edward Beeson was world high-jump champion with a record set at 6 feet, $7^1/_{16}$ inches in 1914. Hazel Hotchkiss Wightman was U.S. National Women's Tennis Singles Champion in 1909, 1910, 1911, and 1919. She also was doubles champion at Wimbledon, and Olympic gold medal doubles winner—both with partner Helen Wills in 1924. On October 24, 1955, Robert A. Boehm, the world's inboard motorboat hydroplane champion, set the record for the 136-cubic-inch engine at 83.89 miles per hour.

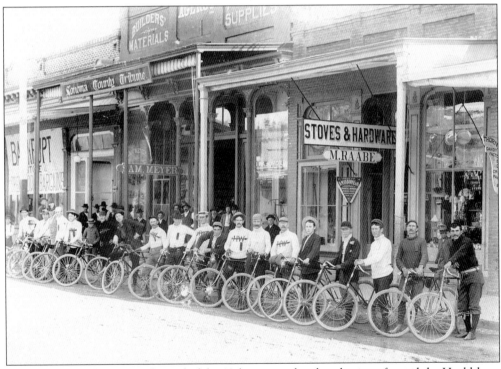

During the bicycle craze at the end of the 19th century, local enthusiasts formed the Healdsburg Wheelmen. The Wheelmen enjoyed riding as a group, showing off their "HW" logo pierced with an arrow. This c. 1890 photograph shows them ready to stream off from the Plaza on well-kept bicycles.

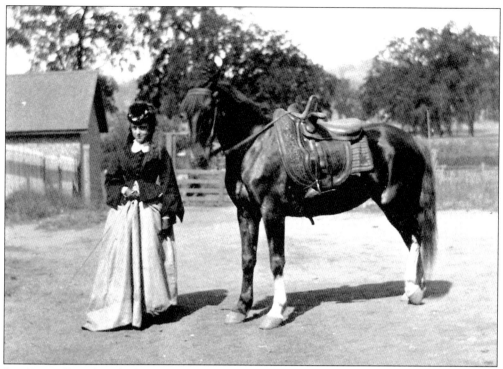

In 1871, Dolly Babcock, dressed for a day of equestrian enjoyment, stands beside her mount in downtown Healdsburg. The propriety and comfort of sidesaddle riding was appropriate for women in that day and age.

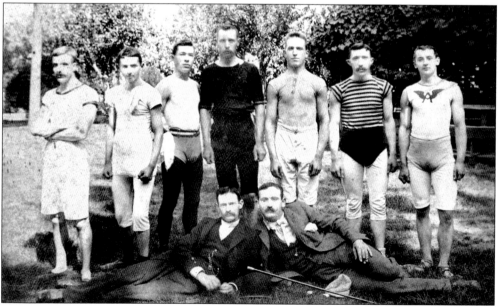

Healdsburg Athletic Club members gather for a photograph, c. 1895. The club was founded in 1894 with 20 members. Members worked out in the gymnasium in the Gobbi Building on Center Street. The two men reclining in front, one smoking a cigar, probably did not share the dedication to conditioning of the other club members.

The twilight baseball league, which began as an experiment in 1930, had caught on by 1932 when eight local teams—representing businesses, service clubs, and other groups—began playing in May on a diamond next to the American Legion Hall on Center Street between North and Piper Streets. New lights were installed for the 1932 season. The property is now part of a shopping center at that location.

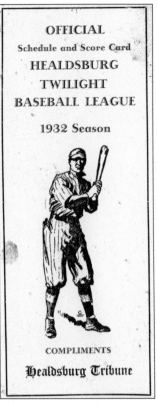

OFFICIAL
Schedule and Score Card
HEALDSBURG
TWILIGHT
BASEBALL LEAGUE
1932 Season

COMPLIMENTS
Healdsburg Tribune

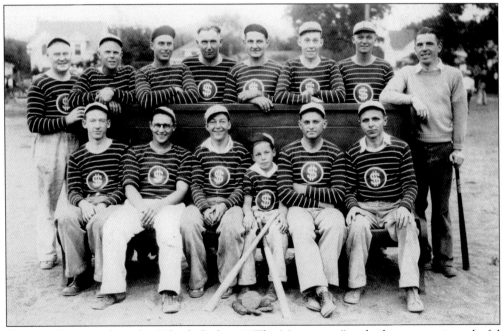

Known affectionately as the "Check Cashers," "The Moneymen," and other even more colorful names, this 1931 Bank of America team played in the highly popular Healdsburg Twilight Baseball League. Manager August Wagele is standing at right.

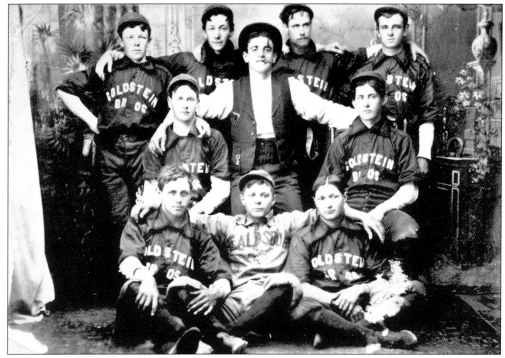

The Goldstein Brothers, both born in Healdsburg, owned a men's clothing store in town and sponsored a popular and successful baseball team. The 1896 team pictured above, from left to right, consisted of (first row) Louis Belvail, "Monk" Taeuffer, and Louie Bacigalupi; (second row) Teddy Lynch, Louis Foppiano, and John Miller; (third row) Fred Huebner, Romeo Passalacqua, Will Neely, and Ernest Hughes.

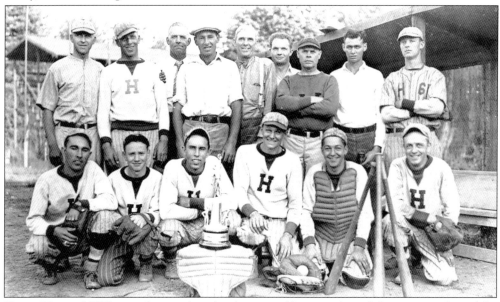

Henry "Cotton" Williams, the standout first baseman (first row, far right), was a member of the 1933 Odd Fellows team. Other members included the hard-hitting Rollin McCord and pitcher Waldo Iversen. The team won the IOOF championship with a 3-2 win over Napa.

In the 1920s, Healdsburg's Prune Packers fielded a formidable semipro baseball team. Named after one of the town's cash crops, the Packers defeated the county opposition and went on to compete against Bay Area semipro teams. Large crowds of 800 and more people attended their home games at Recreation Park. The original Packers disbanded in the late 1920s, although the team was revived in the 1950s.

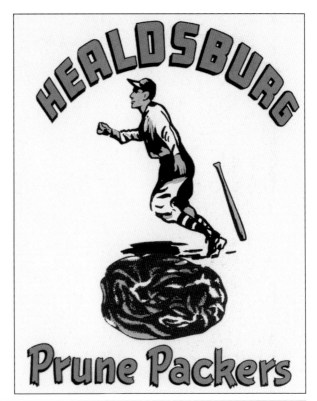

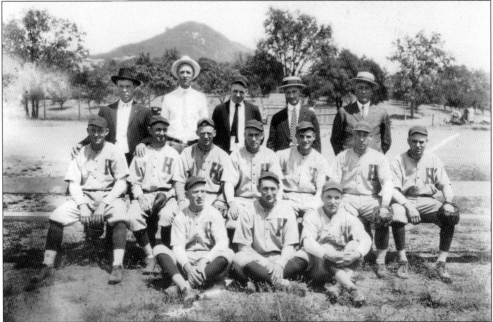

Competing with other semipro teams such as the Santa Rosa Rosebuds and the Petaluma Leghorns, the Healdsburg Prune Packers respectably represented their fruit-producing hometown. Many on the team, which was begun in 1928 and ended in the 1960s, were also prune pickers at some time in their lives in Healdsburg.

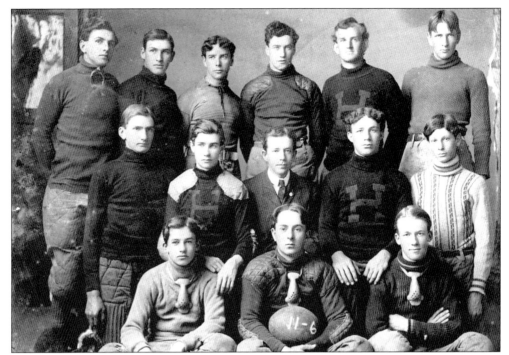

The 1906 Healdsburg High School football team, at and an average of 150 pounds, was one of the heaviest squads the school fielded up to that time. Among the team members on the squad were the McDonough brothers: Melville (middle row, second from left) and Bert and Lester (back row, second and third from left). Track star Fred Young is in the front row, left.

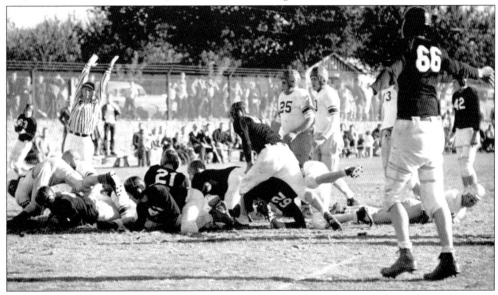

The first Healdsburg alumni football game was played on Thanksgiving Day 1928 and became an annual event interrupted only by World War II. The contest resumed in 1949 with profits from attendance going to the purchase of athletic equipment for the high school. Pictured are the 1957 Healdsburg Greyhounds scoring one of their two touchdowns in a 13-0 victory over the alumni team.

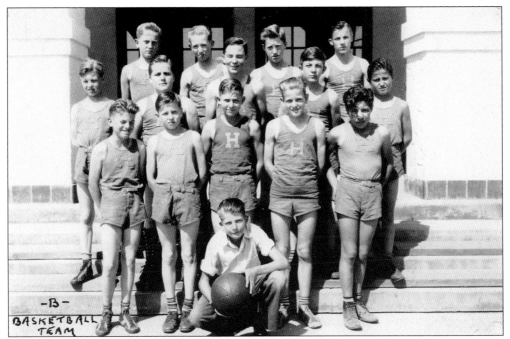

With "H"s emblazoned on their athletic shirts, the 1941 Healdsburg Grammar School boys' basketball team, assembles in front of the school entrance for a group photograph.

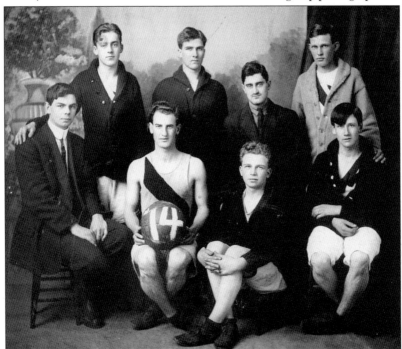

The Healdsburg High School Basketball team of 1914, though short in numbers, was tall in enthusiasm and ability. Pictured here are (first row) Ernest Frellson (manager), Claude Burke (center-captain), Glen Dewey (forward), and Elmer Sandborn (guard); (second row) Sewell Hilgerloh (forward), Albert Hoskinson (guard), Humbert Scatena (coach), and Alfred Parker (substitute).

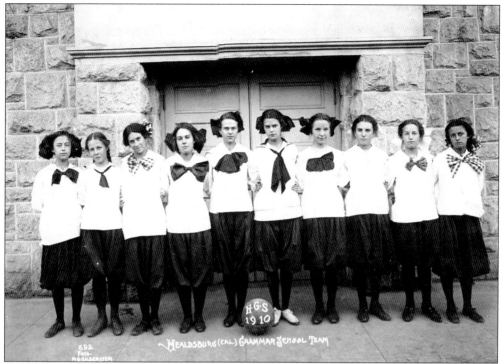

In 1910, members of the girls' basketball team of the Healdsburg Grammar School line up in middy blouses and bloomers. Pictured, from left to right, are Lucile Byington, Marion Whitney, Jean Tevendale, Edna Haigh, Eda Beeson, Loraine McDonough, Claire Heald, Bernice Jaggers, Mildred Coffman, and Helen Hilgerloh.

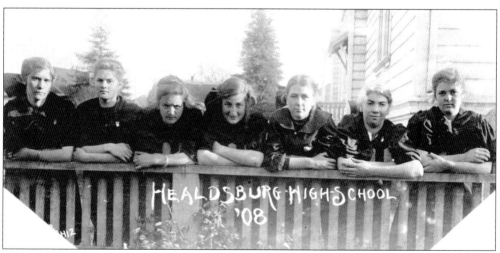

The Healdsburg High School girls' basketball team of 1908 won the Academic Athletic League championship by defeating Cogswell Polytechnic College of Oakland by a score of 16-14. The determined-looking members, who lost only two games, from left to right, are Audrey Walters, Elva Beeson, Aubry Butler, Kathleen Swisher, Gertrude Field, Una Williams, and Bera Mothorn.

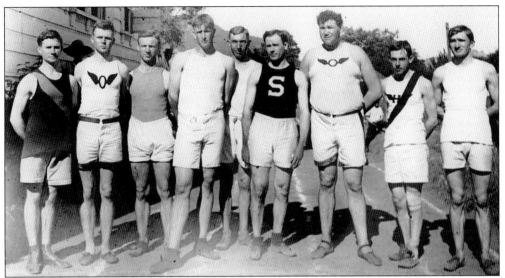

In 1910, Olympic champion Ralph Rose, third from right, and a star-studded assemblage of trackmen reconvened for an alumni track meet with Healdsburg High School athletes. The meet, organized by photographer and runner Mervyn Silberstein, second from right, actually ended in a tie score in points per team, but Rose did set a record in the 16-pound shot put.

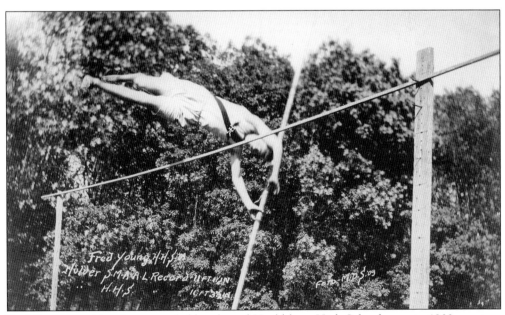

Fred Young, vaulting for a remarkably talented Healdsburg High School team in 1909, went on to become a champion pole vaulter for the University of California, Berkeley. The high-flying Young later became a trusted undertaker in town.

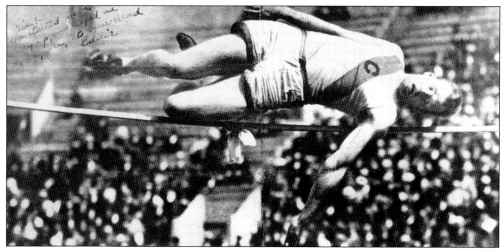

In 1909, local hero and track legend Eddie Beeson shows his form in a record-breaking performance, at a meet in Berkeley for the University of California. Beeson's style of rolling over the bar, sometimes called the "Western Roll" was a precursor to the famous "Fosbury Flop" of the 1970s. This technique of leading with one's shoulders is now the standard in high jump competition.

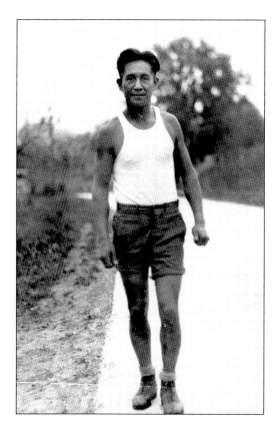

Manuel Cordova, whose Pomo name was *Tuila* (Hummingbird), became a local marathon hero. Born in the Dry Creek Valley, the fleet-footed Native American was a participant in many long distance events, including the grueling 480-mile race from San Francisco to Grants Pass, Oregon, in 1928.

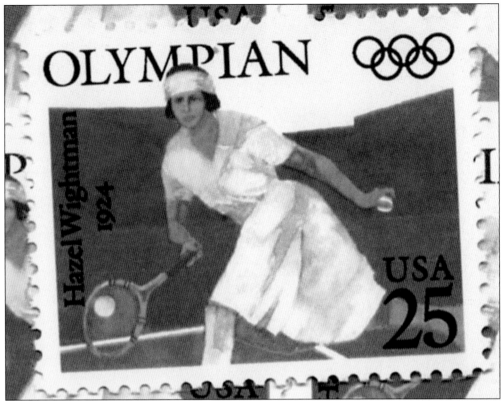

The "first lady of tennis," Hazel Hotchkiss Wightman was known for her aggressive, hard-pressing style of play that set the tone for future players to emulate. She was raised on a 375-acre family farm south of Healdsburg. Winning the Olympic gold medal in 1924, she was honored on this U.S. postage stamp in 1990.

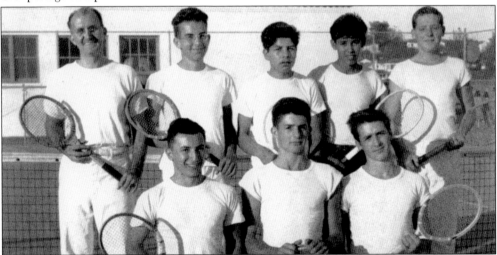

Al Worden's Healdsburg High School championship tennis team of 1949 featured Stan Smith (top row center), who never lost a match in his four years as a Greyhound racquet man. Pictured here, from left to right, are (first row) E. Nicoletti, B. Mazetti, and J. Brooks; (second row) Worden, C. Wilson, Stan Smith, Alfred Elgin, and R. Pierce.

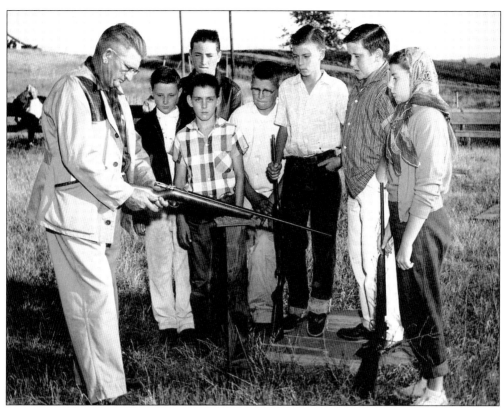

The proper handling of a rifle is demonstrated in 1957 by R. W. Peterson, instructor in Healdsburg's Junior Hunting Safety Course, on the grounds of the Healdsburg Rod and Gun Club. His class includes, from left to right, Dan Brewer, Dean Ross (behind), Joe Brewer, Seth Hartman, Robert Burg, Nathan Cox, and Ann Petray.

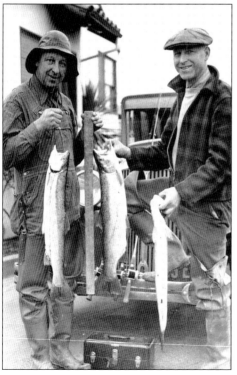

In this 1947 image, Ralph and Jake Tanner proudly display steelhead trout caught in the Russian River. The local hotspots produced many species of salmon for local sportsmen.

Eight

ABUNDANCE AND ENTERPRISE

The logging industry was a strong force in the local economy in the 19th century. Rich stands of redwood and other timber along the Russian River system fed the multiplying sawmills and lumberyards into the 20th century. Rumors of gold never panned out, but mercury, used in gold processing, was discovered in significant amounts in the mountainous region to the north. Little mining communities, which relied heavily on immigrant Chinese labor, sprang up to accommodate the influx of miners, but vanished in hard times. One mining enterprise, taking gravel from the Russian River aquifer for construction purposes, began at the turn of the 20th century and is still pursued.

Pioneer farmers found that the temperate climate and alluvial soil of the surrounding valleys created an agricultural paradise. The abundance of fruit called forth packinghouses and canneries in the late 19th century. It meant seasonal work for hundreds of local women and girls. Over the decades, grapes, hops, and prunes emerged as the chief money crops. The boom years for local hops—prized by brewers as a bitter flavoring agent—lasted from the 1880s to the 1950s. Local prunes also fell out of demand about the same time. At the height of production, blossoming prune trees created a sweeping springtime spectacle.

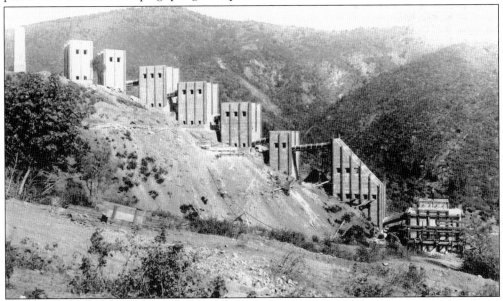

The mountainous area north of Healdsburg proved to be an important source of quicksilver, or sulphate of mercury, which was an essential element in the processing of pure gold and silver. From the 1800s and well into the 20th century, mines and small mining communities revived and expired depending on mercury prices. The Socrates Mine, 22 miles northeast of Healdsburg, crushed and concentrated the cinnabar ore in mountain-side processing plants.

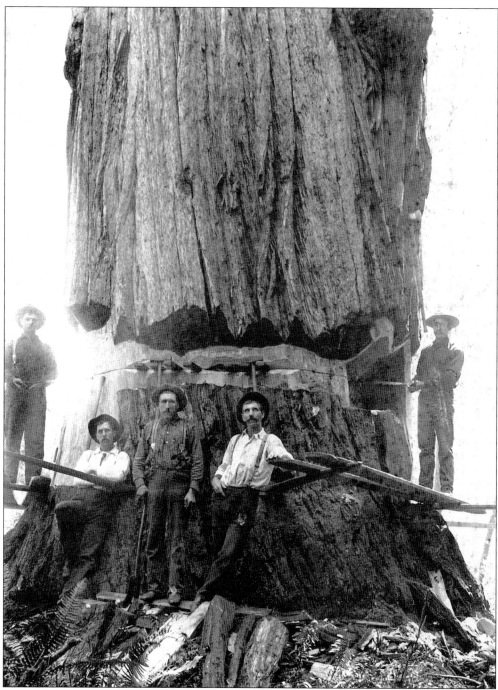

Pioneers discovered rich stands of redwood along the Russian River system in the Healdsburg region. It was a resource that founded the first important industry. Felling a redwood was a daunting, day-long task, pitting a small team of workers with hand tools against a massive trunk, as demonstrated in this *c.* 1900 picture. Redwood lumber helped rebuild San Francisco after its several massive fires.

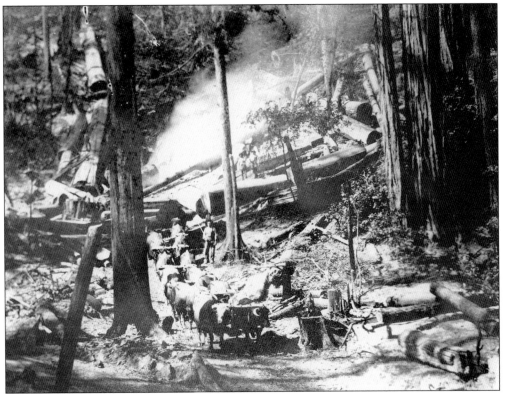

Teams of oxen hauled wagonloads of logs from the lumber camps along the Russian River and its tributaries in the 19th century. Redwood was the most sought-after lumber for building. During the Civil War, redwoods were cut and shipped to the North for use as railroad ties. The arrival of the railroad in Healdsburg in 1871 greatly expanded the markets for local lumber.

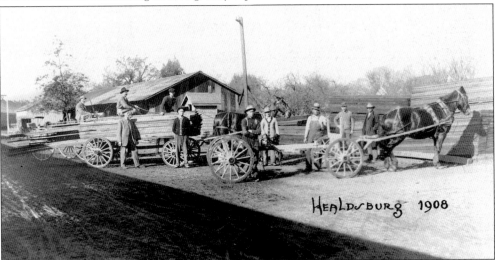

A. F. Stevens, owner of the A. F. Stevens Lumber Company, is the man in the suit in front of the wagonload of lumber. He bought the yard in 1908 and developed it into one of the town's most successful businesses. On his death in 1928, his son Russell took charge. The lumberyard is still in business as the Healdsburg Lumber Company.

The local abundance of tan oak trees, whose bark was used for curing leather, encouraged one of the town's earliest enterprises, the manufacture of leather gloves. This 1872 view shows the Healdsburg tannery of Gordon A. Cook, a native of New York State who came to Healdsburg in 1865 and turned from farmer to glove manufacturer around 1870.

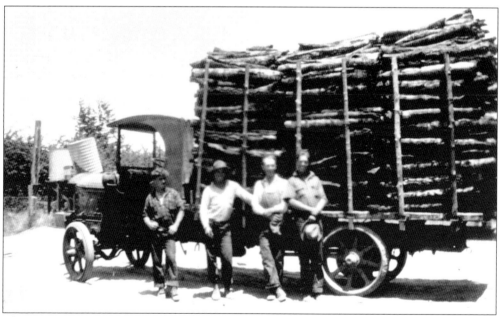

The harvest season for bark from tan oak trees in northwest Sonoma County was in May and June. Workers, based in woodland camps, peeled the tannin-rich bark from the trees and hauled it out in sections to manufacturers. Mules pulled the wagons in the early years. The harvesting persisted into the 20th century. Here is a typically loaded motor truck, c. 1920.

86

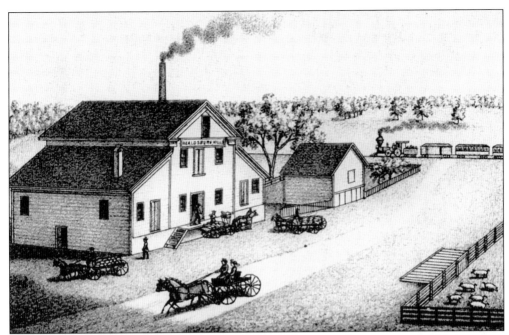

In the 1870s, farmers in the fertile valleys around Healdsburg raised grain on much of their acreage in an era before crop specialization—grapes, hops, and prunes—became the mainstay of agriculture in the area. The Healdsburg Flouring Mill, sketched here in 1877, was located on the south side of town. A railroad engine, a certain sign of progress, steams past in the background.

This advertisement is from a March 1875 edition of the *Russian River Flag*, a Healdsburg weekly. T. C. Carruthers and his associates were regular advertisers in the newspaper, inviting local farmers to bring in their wagonloads of grain to be ground into flour.

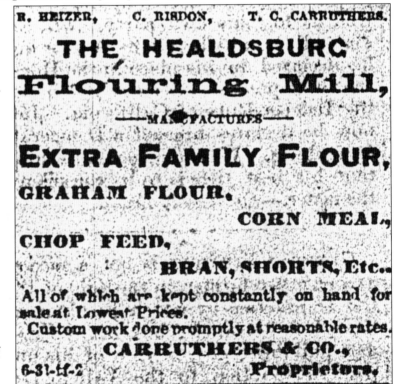

R. HEIZER, C. RISDON, T. C. CARRUTHERS.

THE HEALDSBURG
Flouring Mill,
—MANUFACTURES—
EXTRA FAMILY FLOUR,
GRAHAM FLOUR,
CORN MEAL,
CHOP FEED,
BRAN, SHORTS, Etc.

All of which are kept constantly on hand for sale at Lowest Prices.
Custom work done promptly at reasonable rates.
CARRUTHERS & CO.,
6-31-tf-2 Proprietors.

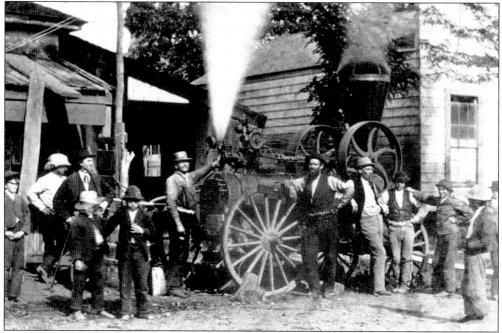

In 1874, the shriek of steam released from the boiler valve of a threshing machine pierces a May day just south of the Plaza. The note on the back of the original image indicates Clarence Downing, the brother of the photographer, had just completed a repair of the machine and was returning it to work in the grain fields. He soon left town to become a successful mechanical engineer in San Francisco.

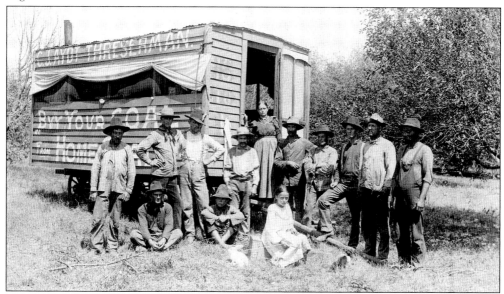

C. J. Aydt family members and workers made up a team of threshers who, in the late 19th century, moved from ranch to ranch helping to harvest the grain crops that were an important source of farm revenue in those days. The horse-drawn, cabin-on-wheels served as cookhouse and bunkhouse. Some workers slept underneath it. Harvest time provided an opportunity to advertise coal for the coming winter.

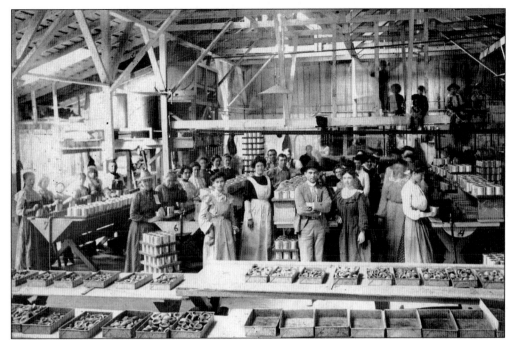

In the late 1880s, canneries and food packing plants began popping up in Healdsburg. The town shipped thousands of cases of fruit and vegetables to the East Coast and Midwest, as well as Europe and Australia. The work was seasonal and performed predominately by women, as demonstrated in this group photograph of the peach canning process at the Magnolia Cannery. The industry was important to the local economy and lasted well into the 20th century.

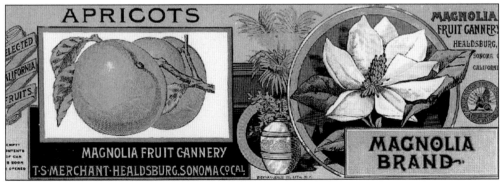

The wooden crates carrying canned fruits and vegetables in the 19th century bore identifying labels that developed into eye-catching artwork by the mid-1880s in California and other states. The Magnolia Fruit Company of Healdsburg advertised in 1888 that it would need to hire about 200 to 250 women, boys, and girls to work preparing and canning local fruit crops.

The Healdsburg Enterprise

ONE HUNDRED AND FIFTY THOUSAND PRUNE TREES ARE BEING PLANTED

PRUNE INDUSTRY OF NORTHERN SONOMA GROWING BY MUCH PLANTING

Two Thousand Acres to Be Set Out Before Spring—Partial List of Those Setting Out Prune Trees—Steady Growth for Years

acres.

C. D. Masters, Alexander Valley, 11 acres.

Perry McPherson, Alexander Valley, 5 acres.

Bud McPherson, Alexander Valley, 8 acres.

A. L. McPherson, Alexander Valley, 6½ acres.

Sarah Kelley, West Side, 9 acres.

Demand for prunes from the Healdsburg region intensified with the outbreak of World War I in 1914. Local prunes were "known the world over for their excellent quality," according to the *Healdsburg Enterprise*. There was a rush to plant new prune orchards in 1916. In an age before widespread refrigeration, prunes were a welcome fruit dish in the winter and spring months. At the peak of prune plantings in California in 1929, some 171,330 acres, or 267.7 square miles, were planted in prune orchards.

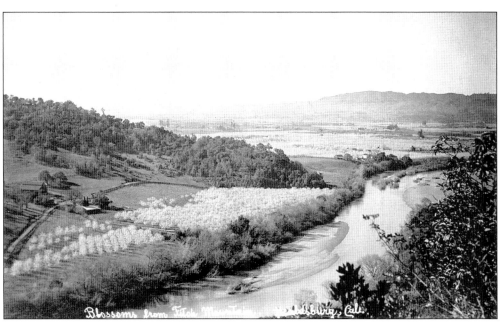

One of the most delightful aspects of the prune-producing era in the Healdsburg area was the explosion of prune blossoms in the spring. This is a westerly view from Fitch Mountain overlooking the blossoming orchards of the Minaglia Ranch on Bailhache Avenue. The Russian River flows toward town in the foreground.

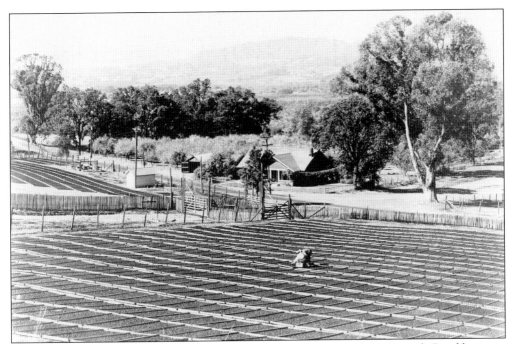

Trays of prunes are spread out for sun drying at the Hotchkiss Ranch on Eastside Road between Healdsburg and Windsor in about 1900. This was the family home of Hazel Hotchkiss Wightman, who became an Olympic tennis star. Both towns claim her as their hometown champ.

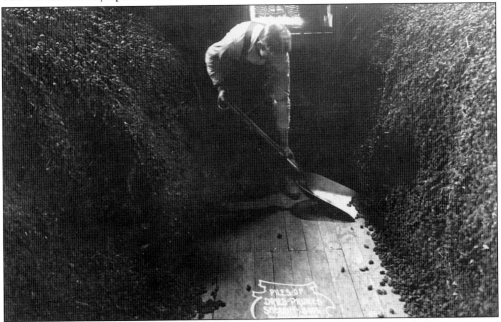

The sheer volume of prunes handled by Healdsburg's Sherriffs Brothers Packing House, one of the largest in Sonoma County, is demonstrated by this c. 1918 image of a worker maintaining banks of the dried fruit. During a bumper crop, about 5,000 tons of prunes went through the packinghouse in the south part of town near the railroad tracks. Sherriffs sold the business in 1922 to the California Prune and Apricot Growers.

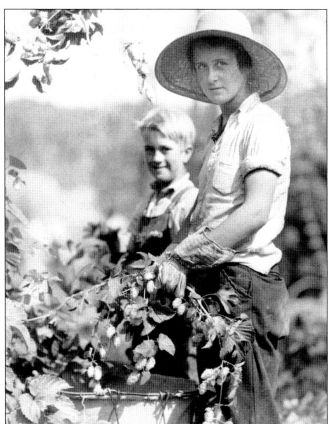

Two young hop pickers strip vines at the Chisholm Hop Ranch. The long gloves provided protection from the irritating rough leaves and stems. The large hat shaded the woman from exposure to the late summer sun. It was hot sticky work, paying the pickers 1½¢ per pound in the 1930s.

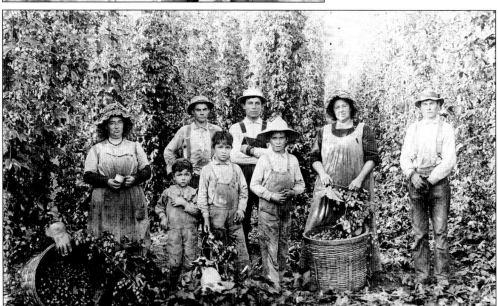

During a typical harvest in the early years of the 20th century, whole families camped near the hop fields, and parents and children spent the day stripping the hops from the vines. Migrant workers joined the locals in the harvesting.

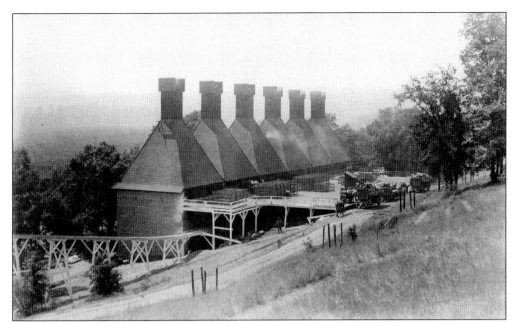

The Wohler Ranch hop kilns were among the many operating around Healdsburg in the early decades of the 20th century. Hop blossoms were stripped from the vines and taken to the kilns where they were dried and shipped to be used in the brewing of beer. Hops were first planted in the area in the 1870s. By the 1960s, they were no longer a commercial crop because of a fungal blight and a switch to lighter-tasting beer.

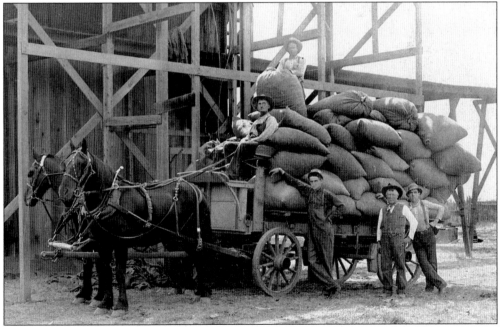

Driver Matt Hughes delivers a wagonload of hops to the Wohler Ranch hop kiln, c. 1910. In the harvest season, a stream of horse-drawn wagons delivered the crop to the drying kilns of the region. The dried hop blossoms were shipped to brewers who used them in the beer-making process to add a distinctively bitter flavor.

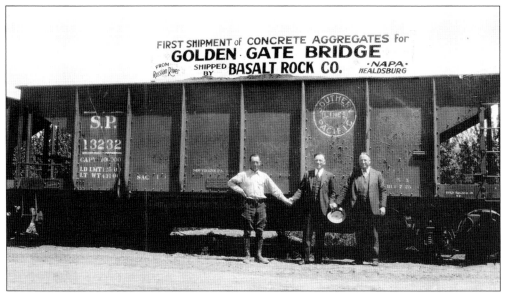

The departure of the first freight load of gravel for the building of the concrete foundations of the Golden Gate Bridge was a ceremonial moment for Healdsburg's Basalt Rock Company in 1935. Developer John D. Grant, right, was one of the first in the early 20th century to mine the deep gravel layers of the Russian River aquifer. It became an important local industry during the construction expansion after World War II.

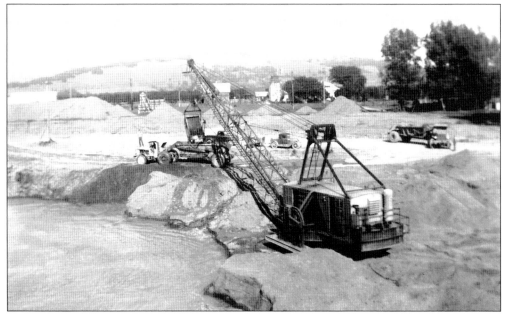

The shovel and horse-drawn wagon of the early days of gravel mining have been replaced by the high-extraction equipment in this *c.* 1940 picture. The production method, mining by drag line, involves swinging the bucket into the Russian River and dragging it ashore holding about three cubic yards of sand and gravel. The load is emptied into a waiting "cat wagon." (Courtesy of Rand Dericco.)

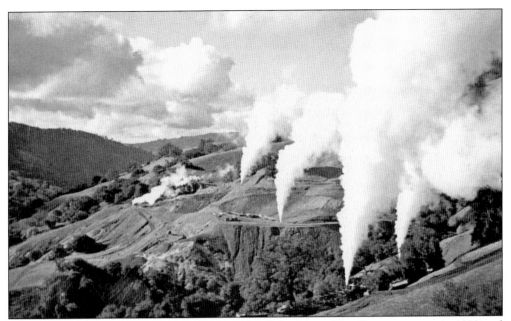

Healdsburg developer John D. Grant optioned 2,500 acres in The Geysers canyon in 1920 and drilled a well, finding steam at 200 feet. He harnessed the steam for a power plant and began supplying Healdsburg with supplemental electricity. Contemporary equipment could not withstand the corrosive effects of steam, and it wasn't until the mid-1950s that large-scale power production was feasible in The Geysers field.

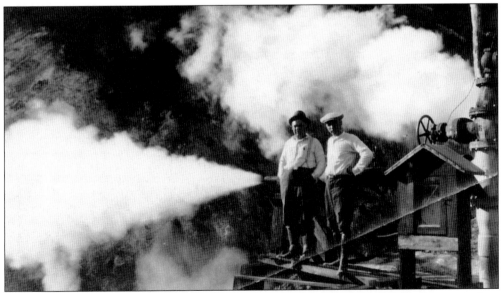

The geothermal energy of The Geysers was harnessed to provide electricity for the resort when entrepreneur John D. Grant, left, installed the first natural steam generator in America in 1923. Grant also established the first gravel grading plant in California on the Russian River in 1906.

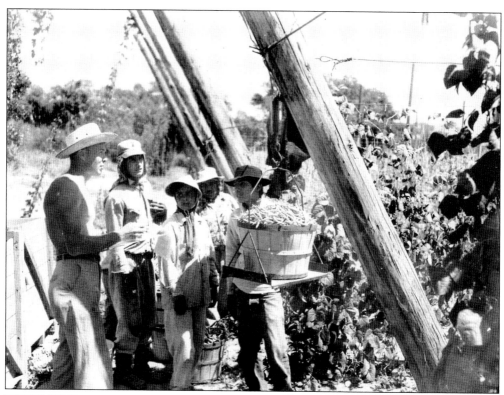

Hispanic migrants also provided labor to harvest the diverse crops grown in the Healdsburg area. Pictured are members of the Moreno family weighing in a basket of string beans they have picked at the Baudau ranch. At left is Robert Jackson, a Santa Rosa Junior High School teacher, who worked as a field representative and weigh master at the ranch during the summer months.

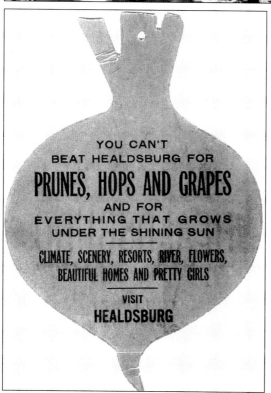

YOU CAN'T
BEAT HEALDSBURG FOR

PRUNES, HOPS AND GRAPES

AND FOR
EVERYTHING THAT GROWS
UNDER THE SHINING SUN

CLIMATE, SCENERY, RESORTS, RIVER, FLOWERS,
BEAUTIFUL HOMES AND PRETTY GIRLS

VISIT
HEALDSBURG

This promotional item from early in the 20th century, believed to be an ink blotter, relies on a heavy play-on-words to deliver its message. The beet shape is a visual reference to the "You can't beat Healdsburg" theme.

Nine

GRAPES IN PROFUSION

The vibrant wine industry now established in the Healdsburg region has deep roots in the community. In 1862, the town's first winemaker was George Miller, a Swiss native who built his Sotoyome Winery north of the Plaza. In 1873, John Chambaud, a French immigrant, established a stone winery on the southeast side of town near the new railroad tracks. His first vintage, from grapes grown by others, amounted to 20,000 gallons. Two brothers from Tuscany, Giuseppe and Pietro Simi, bought the Chambaud winery and by the 1880s were producing from 40,000 to 70,000 gallons of wine annually for the San Francisco market. They outgrew the Chambaud winery. In 1890, they built a bigger stone winery on the road north of town. The Simi winery building is still in use today.

The early winemakers struggled. *Phylloxera*, a root-eating pest, attacked the vineyards late in the 19th century. Nothing worked against the infestation until growers grafted their European-bred vines to resistant root stock of native American vines.

Prohibition lasted from 1919 to 1933. In 1939, the market price for grapes was $16 a ton, about the same price that was paid in 1900. It wasn't until the 1970s that wine grapes began emerging as the dominant agricultural crop of the region. The heritage of these persevering growers and winemakers is all around us.

The hard labor involved in tending new vineyards without mechanized equipment is illustrated in this *c.* 1918 image of the Dry Creek Valley. Carlo and Vince Davini, twin brothers, have a horse and a hand pick to till the soil on their property off Lytton Springs Road which is beyond the barn on the right. The vineyard is believed to have been planted with red wine grapes, likely zinfandel.

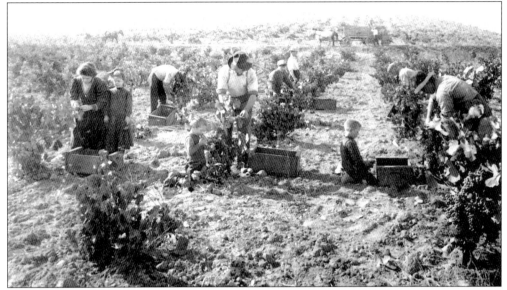

Picking grapes was a family affair on the Simi vineyards, *c.* 1925. Isabelle Simi Haigh, daughter of a founder of the winery, and her daughter Vivien about 10 at the time, are together on the left of this picture. The Simi Winery made sacramental wine during Prohibition (1919–1933) and sold off parcels of property to survive. When Prohibition ended, Simi was said to have some of the finest bottling of aged Sonoma red wine.

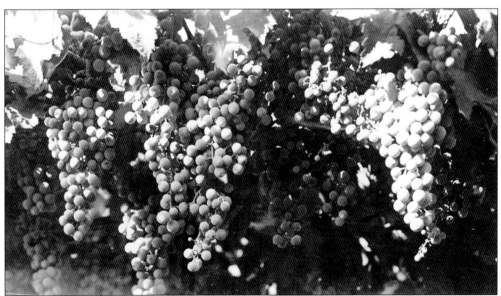

Grapes on the vine in northern Sonoma County benefit from a climate that offers a growing season of hot, dry days tempered by cool nights.

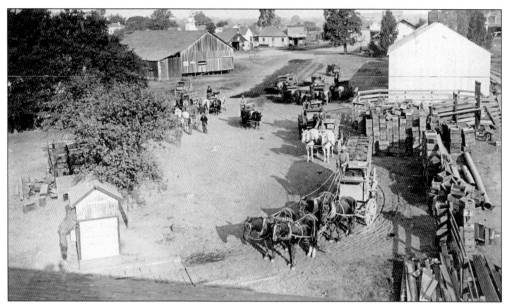

Teams haul grapes from the Hopkins ranch on Westside Road to be crushed in Windsor, c. 1900. The driver in the foreground is Marshall McCracken. In 1930, the ranch was bought by Osborne and Alice Aileen White. The Episcopal Diocese of California took over the property in 1947 to use as a retreat. Now known as The Bishop's Ranch, the beautiful site has facilities available to the public by reservation.

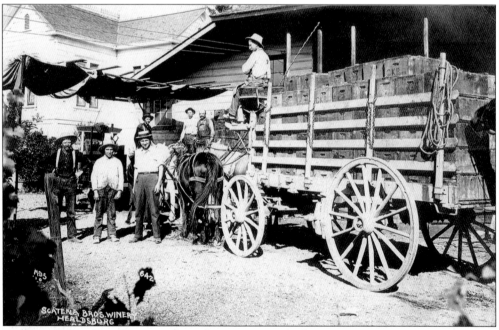

The Scatena Brothers Winery, a large frame structure built in 1890 on Grove Street, receives a load of grapes from the Porter ranch on Westside Road (now the MacMurray ranch) during the c. 1910 crush. The winery survived Prohibition by making medicinal and sacramental wine. The property was sold in the 1940s and now is the location of the Seghesio Family Vineyards winery and tasting room. (Courtesy of the Gail Unzelman collection.)

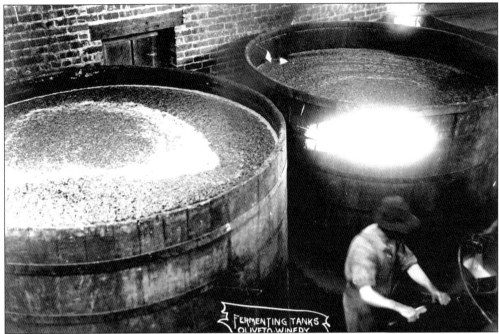

The Oliveto Winery, with Domenico Lorenzini as principal owner, was active from 1898 to Prohibition in 1919. Here are redwood fermenting tanks around 1900. Some 2,000 tons of grapes from Sonoma, Mendocino, and Lake Counties were crushed annually and the wine sold from the Oliveto depot in San Francisco.

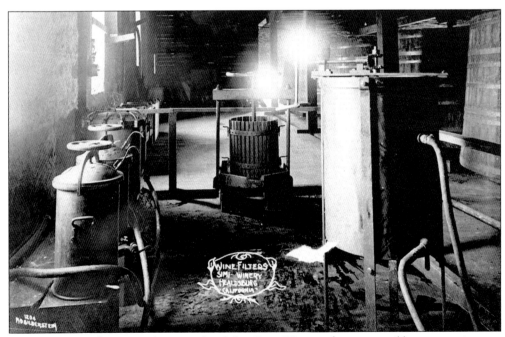

This Mervyn Silberstein photograph of the Simi Winery shows wine filtering equipment characteristic of the early 1900s. An old wine press is pictured in the center.

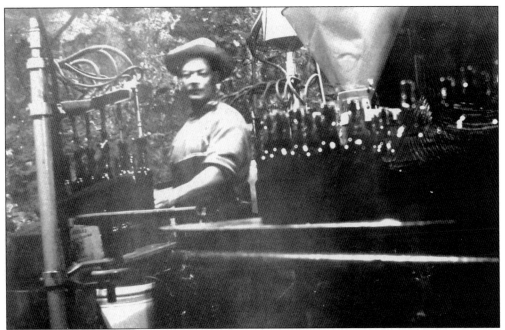

A man operates a bottle filler at Simi Winery, c. 1900. Wine bottles were filled largely by hand until automated bottling lines became common in the 1960s. In the 1970s and 1980s, with the increase in demand for fine wine, there were innovations in the California wine industry that advanced the efficiency of packaging systems and improved winemaking technology.

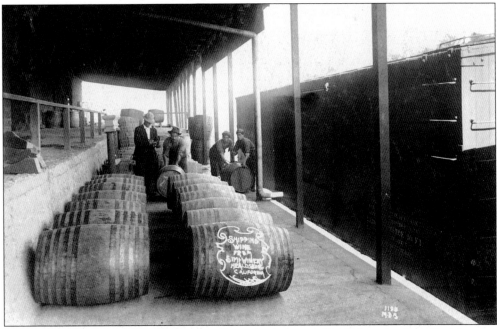

The stone building of the Simi Winery, still standing in north Healdsburg by the railroad tracks, was built in 1890 by Guiseppi and Pietro Simi, brothers who emigrated from their native Italy. They founded the winery in 1874, and became American citizens in the 1880s. Here, c. 1900, winery workers are loading barrels of wine from the winery dock into a railroad car.

101

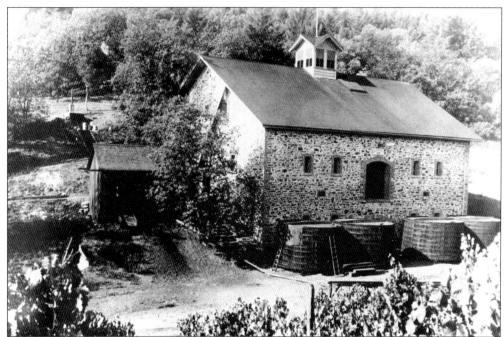

The Paxton Winery building, erected in 1887, was designed by Hamden W. McIntyre, a leading winery architect of that era. McIntyre also designed many well-known Napa Valley wineries, including the Christian Brothers Winery and Inglenook Winery (now Niebaum-Coppola). The 1906 earthquake collapsed the four-foot-thick walls of the Paxton Winery and only a small portion of the stone work still stands. Wealthy John A. Paxton also built the mansion on Madrona Knoll, now known as Madrona Manor.

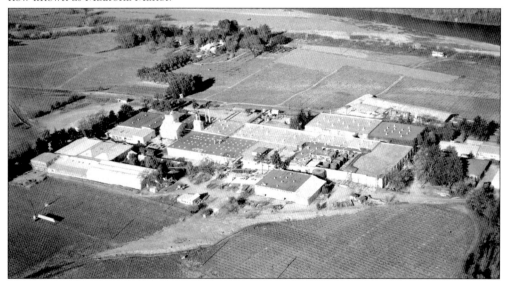

In 1881, immigrant Andrea Sbarboro conceived of the Italian Swiss Agriculture Colony as an investment property. Italian and Swiss families were invited to settle, farm, and invest in the land some 12 miles north of Healdsburg. They created the village of Asti. The Italian Swiss Colony winery, shown here c. 1947, produced award-winning wines and had a storage capacity of 10 million gallons.

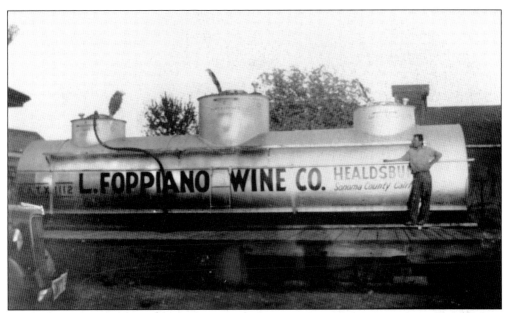

Louis J. Foppiano stands on one of the railroad tank cars leased by the company in the late 1930s to ship bulk wine to New York for bottling. The tank cars were brought to a rail siding near the Foppiano winery, which still produces wine at the location southwest of Healdsburg. In the late 1930s, with the effect of Prohibition (1919–1933) still being felt, it was more economical to ship in bulk rather than bottle locally. (Courtesy of Louis J. Foppiano.)

A stream of red wine runs down a roadside ditch from the Foppiano ranch, southwest of Healdsburg. In 1926, Prohibition authorities ordered the dumping of the wine stocks on hand. A crowd, numbered at between 30 and 40 men and women by the local press, gathered to scoop up the wine "as one might scoop water from a babbling brook." (Courtesy of Louis J. Foppiano.)

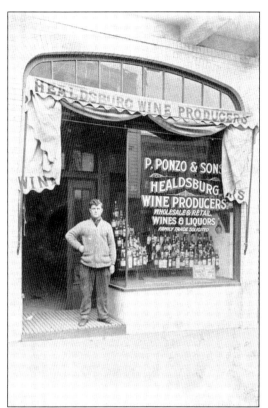

Phil Ponzo Jr. of Dry Creek Valley stands before the Healdsburg Wine Producers store, which he and his father established around 1915 on Vallejo Street in San Francisco. It was a bold move for local vintners to market in the big city. Father and son report "a good demand for their wines," the *Healdsburg Enterprise* said. (Courtesy of Bunny Lewers.)

Isabelle Simi Haigh and her husband, Fred Haigh, enjoy a relaxing moment at a dining table complete with glasses of red wine, *c.* 1940s. Wine was served daily at dinner by families of Italian origin. It was hard for them to understand how a custom followed for centuries in the old country could be repressed in the United States during the Prohibition years.

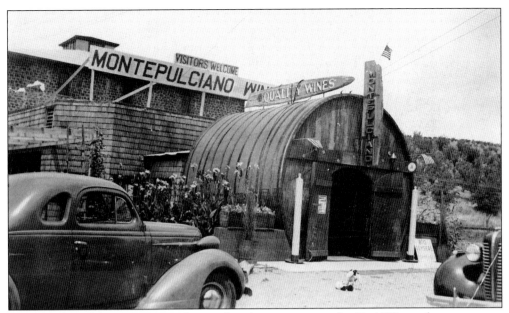

An old redwood fermentation tank served as the tasting room for Simi Winery for many years. Beginning in 1904 when she inherited the winery, Isabelle Simi Haigh worked here selling wine and managing her winery. In the early days, the wine often was labeled Montepulciano after the Italian wine-growing area where the founding Simi brothers were born. The tank was used as the Simi tasting room until the mid-1970s, when the present tasting room was built.

Isabelle Simi Haigh and her husband, Fred Haigh, seated on the right, join in the hospitality of the tasting room within the redwood tank at Simi Winery in an image that appears to date from the 1950s. The wide array of wines on the tasting table includes an unopened bottle of champagne. A cork-opener is clamped to the table top on the right.

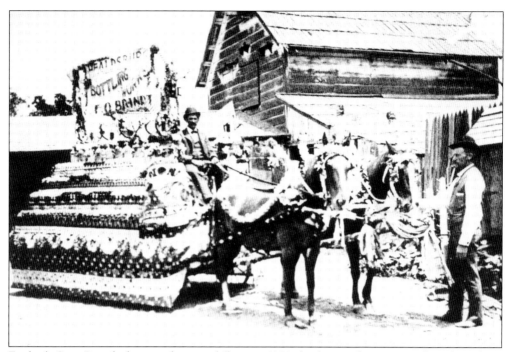

Fredrick Otto Brandt drives a decorated float, c. 1911, displaying the variety of products from Brandt's bottling firm. Even the horses were decorated for this Fourth of July parade. Brandt, a German immigrant, settled his family in Healdsburg in the late 1880s, and started a brewery.

During the late 1890s, F. O. Brandt's brewery on University Street between Matheson and North Streets began bottling beer from other breweries and manufacturing flavored cream sodas and seltzer water. Brandt promoted his company as "Healdsburg Soda and Bottling Works." By 1908, the manufacture of ice had become such an important function that the name of the company was changed to "Healdsburg Bottling and Ice Works."

Ten

CALAMITIES AND REJOICING

A farm town located by a temperamental river in earthquake country was destined to experience bad times. In the good times, the townsfolk loved a celebration. The Plaza and the river under the bridges were natural sites for elaborate, fanciful occasions involving a huge investment in time and attracting visitors from around the county. One annual tradition in the 19th century was for men to put on knights' costumes and try to lance wooden rings from horseback. At the turn of the century, floral parades around town and water carnivals on the river were ruled over by young women elevated to ceremonial queens with full courts. Community spirit also went into good causes; the town "adopted" a U.S. Army battalion in the Korean War.

On the down side, the great earthquake of 1906 destroyed a three-story building on Healdsburg's Plaza and damaged other structures. There were concerns every winter about the Russian River overflowing its banks after heavy rainstorms. One of the worst floods, in 1937, inundated hundreds of acres of crop land and resort property. The Depression in the 1930s weighed heavily on the town despite morale-building attempts. Some of the unemployed found temporary jobs with the Works Progress Administration (WPA).

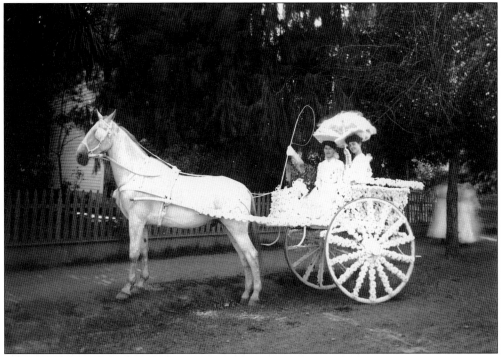

Mabelle Shelford and Florence Barnes pose in a flower-decorated rig under a pretty parasol in preparation for the 1904 Floral Festival parade.

This postcard-sized invitation promised Healdsburg's third flower festival in 1904 would be better than the previous two, and "those were accredited as being among the best . . . in the State." The other side featured Healdsburg's city hall—"the finest in the county"—and noted the Plaza was adorned "with streamers of electric lights from the four corners."

A formal portrait of the queen of the 1909 Water Carnival and her court in full regalia shows how seriously Healdsburg took the coronation. Queen Stella Lufkin was described in the local press as "one of Healdsburg's most charming belles."

"Queen Flora" Isabelle Simi reigned over the 1904 Floral Festival. A few months following the festival, her father died and the teenaged Isabelle took over the operation of the Simi Winery. The winery is still in operation in Healdsburg today.

Alice Haigh, the 1896 Floral Festival Queen, and her regally attired court ladies and small attendants gather for a formal portrait. Standing, from left to right, they are (first row) Zoe Bates, Bert McDonough, princess Julie Mehrtens, queen Alice Haigh, Van Whitney, and Nettie Barnes; (second row) Violet Luedke, Edna Biddle, Nellie Petray, and Lena Zane.

Healdsburg's 1896 Floral Festival featured a popular parade of decorated carriages and bikes and the coronation of a festival queen. Two other festivals were held with equally great success in 1895 and 1904.

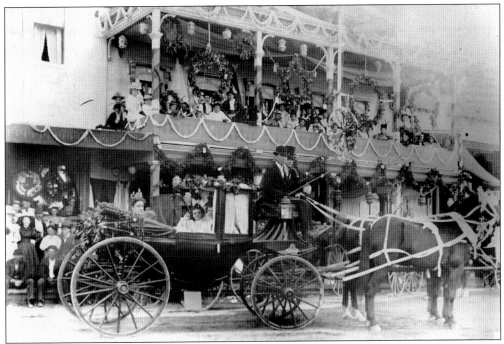

Queen Emma Meiler of the 1895 Floral Festival and her court make the royal circuit of the Plaza lined with spectators. Behind the carriage, the Union Hotel, decked with bunting, offered choice viewing seats on the second-story veranda. The floral festivals at the turn of the century evolved from May Day celebrations in the 1870s. The coronation of the queen in 1895 opened a three-day celebration.

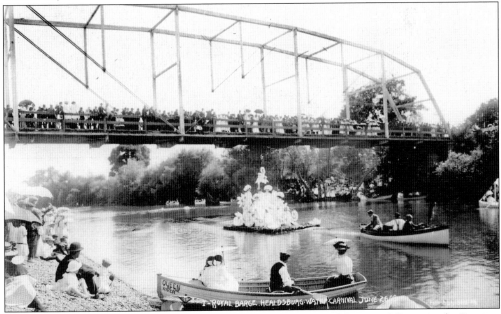

The royal barge passes under the railroad bridge in a procession of decorated floats on the Russian River during the 1909 Water Carnival. The celebration was first held in 1905 and included diving exhibitions from the bridge and fireworks at night.

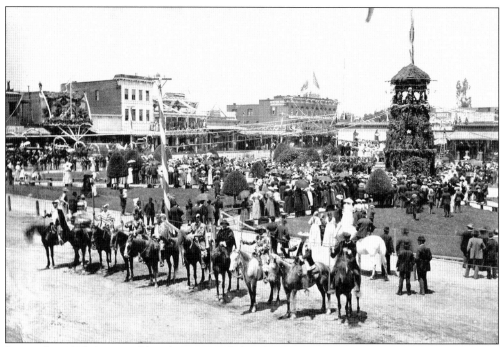

Pictured *c.* 1895, Mounted knights escorted the Floral Queen's royal carriage to the Plaza and later participated in the tilting tournament. Two teams of five men each attempted to spear the rings hung under arches on Center Street.

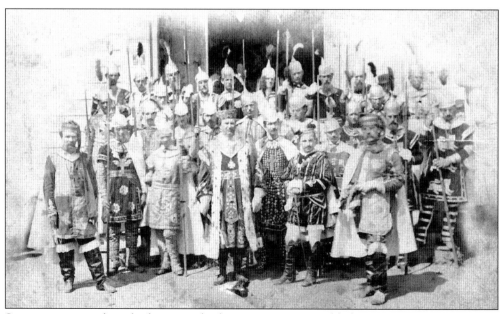

Store owners, smithies, barkeeps, and other townsmen assembled in costume *c.* 1877 for the annual May Day Festival and Knighthood Tournament, first held in Healdsburg in 1857, the year the town was founded. The "knights for the day" tried to catch wooden rings with the point of a seven-foot lance while galloping on a horse.

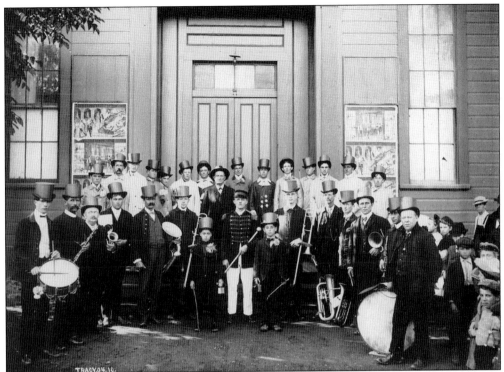

In 1910, the Pastime Minstrels and the Healdsburg Town Band assemble in front of the highly popular Truitt's Opera House on Center Street. As early as 1888, Truitt's theater was featuring social dances, dramas, musical concerts, and lectures. In 1891, the Healdsburg Minstrels gave their first performance there. Roland Truitt, a showman himself, is in the center of the second row of this picture, behind the band master.

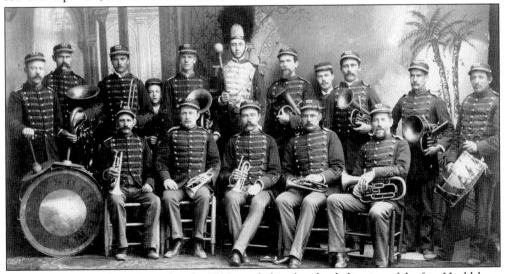

The Sotoyome Band was formed in the 1880s, and played at the dedication of the first Healdsburg City Hall in 1886. Although the band had only 15 members, they played a full program of marches, waltzes, and other selections. The popular band delighted crowds through the early 1900s at their Saturday night open-air concerts in the Plaza.

In 1924, the Healdsburg Chamber of Commerce held a slogan contest to promote its importance as a prune-growing center. The contest was widely publicized and there were more than 2,500 entries competing for the $100 prize for the best 10-words-or-less slogan. The winner, "Healdsburg: the Buckle of the Prune Belt," is displayed on this c. 1930s float carrying a bowl of paper mache prunes. The young woman standing on the right is Elsie Nardi. (Courtesy of Francis Passalacqua.)

Reversing the order of things in the usual Squeedunk manner, a white mule pushes along a carriage equipped with a giant navigation wheel. An amused crowd lines the Plaza as the vehicle occupied by Ted Garrett and Donald Brown passes in a c. 1927 Squeedunk parade. The Squeedunks originally were formed in 1876 in reaction to the patriotic outpouring of the centennial year.

In the mid-1950s, the Rose Parade through downtown Santa Rosa gave Healdsburg a chance to show off the tourist advantage of having the Russian River at its doorstep. The young women being towed by the Healdsburg Boat Club were promoting a forthcoming Fourth of July celebration on water. During the summer, the club organized boating picnics on the river every Wednesday evening.

A bucking automobile is a typical feature of a Squeedunk parade, c. 1920s, during a revival of the antic group activities in Healdsburg. The Squeedunks were formed in 1876 in a humorous reaction to the outpouring of the centennial year patriotism. For about 40 years, they followed community parades on the Fourth of July with their own burlesque procession.

A cast of some 70 men, half of them impersonating women, presented two performances of "When Men Marry" in the American Legion Hall in April 1936. Prominent citizens of the town, the *Healdsburg Tribune* said, "cast aside their somber business suits" to play matrons, vamps, and

fashion plates. The production, a benefit for a youth baseball team, involved high society antics, but the *Tribune* admitted it "didn't have much of a plot."

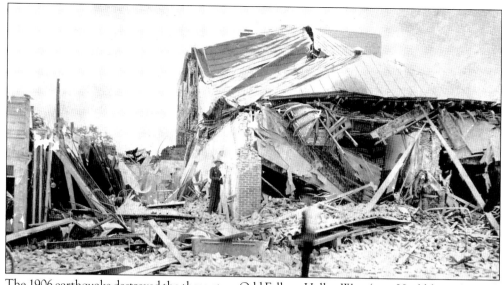

The 1906 earthquake destroyed the three-story Odd Fellows Hall at West (now Healdsburg Avenue) and Matheson Streets. It was the worst damage in town and the single largest loss at $15,000. Next to it on the left, the Cohen Building, which housed a furniture business, was flattened.

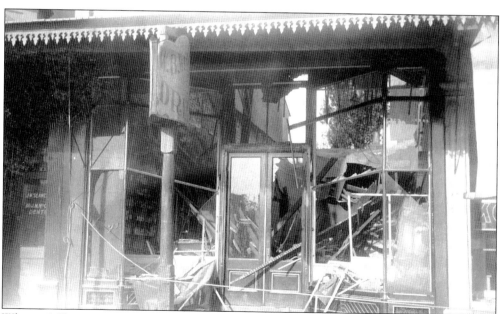

Whitney's Pharmacy on Center Street sustained major damage in the 1906 earthquake when the falling walls of the Masonic Building crushed its roof. Despite pharmacist Whitney's $6,000 loss in the disaster, he set up and sold his remaining merchandise in the bowling alley.

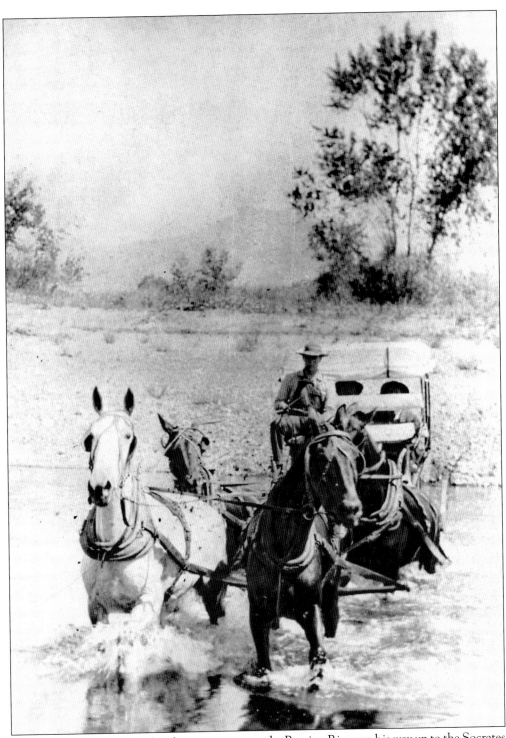

Will Cummings guides his four-horse team across the Russian River on his way up to the Socrates quicksilver mine with a load of supplies. He forded the river because the Alexander Valley bridge was destroyed in the 1906 earthquake.

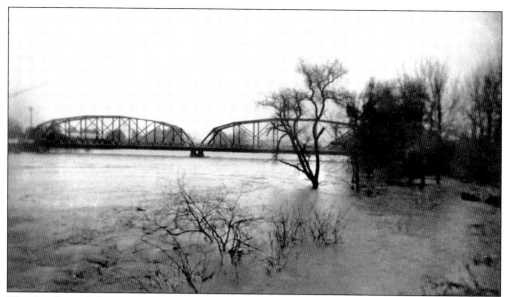

The flooding of the Russian River in December 1937 inundated hundreds of acres of farm and resort land and threatened the two bridges at Healdsburg. This image looks south at the Redwood Highway bridge.

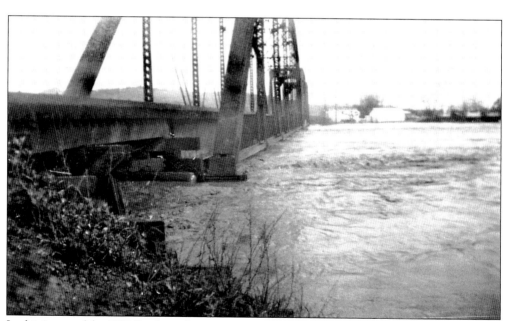

In this image of the 1937 flooding, the water surges up to the superstructure of the railroad bridge. During a later flood, rail cars filled with gravel were left on the bridge to help hold it in place, lest the raging waters sweep it away.

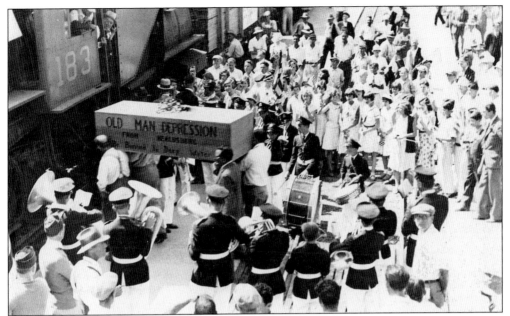

On April 20, 1933, Healdsburg tried to lift the spirits of the community by holding a funeral for "Old Man Depression" and taking the casket in a procession to the railroad station. Waiting was a promotional freight train loaded with redwood lumber to be distributed to yards throughout the Redwood Empire in anticipation of a building boom. The casket was loaded aboard the train. The Depression continued.

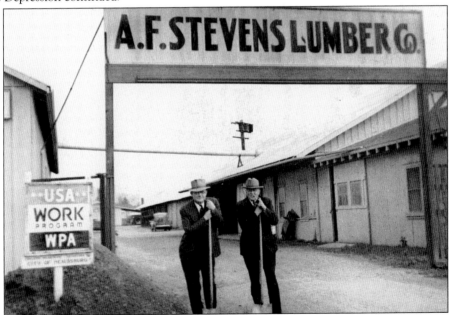

The Works Progress Administration (WPA), which put to work millions of unemployed men during the Depression, provided labor for public improvement projects in Healdsburg. The A. F. Stevens Lumber Company was part of the effort. Here Russell Stevens, son of the company founder, left, and a colleague lean on shovels in the classic pose of WPA workers taking a break. Critics of the program thought there were too many breaks.

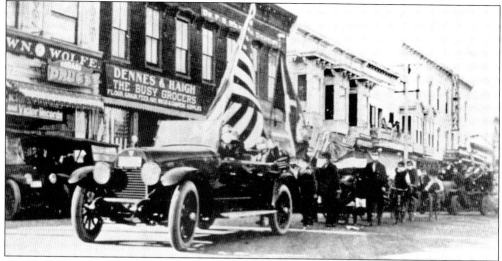

On November 11, 1918, a spontaneous Armistice Day parade rolls around the Plaza. The lead automobile carries Mayor George Brigham Jr., with the Stars and Stripes, and town poet Julius M. Alexander with the flag of peace he designed for a newspaper contest. The face masks were a precaution against the influenza pandemic which began in World War I and caused deaths in Healdsburg.

JAIL REGISTER

NUMBER	NAME	DATE RECEIVED	ACCOMPANYING OFFICER	CHARGE	Sex	Age	RACE	PLACE OF BIRTH
08	Phill Gilbried	Oct 22	W Studer	Drunk	male	44	amer	Healdsburg
09	Rich Seatena	" 24	McCord	Speeding	"	19	Ital	S F
10	Rodger Gilbried	" 30	S rucbord	Drunk	"	44	amer	Healdsburg
11	J H O'Leary	" 30	S rucbord	" "	"	40	Irish	Illinois
12	Jos Sinclair	" 30	mason + Stu	Beg	m	68	am	—
13	John Cook	Nov 6	mason	Drunk	m	57	amer	Healdsburg
14	Dan Kosler	" 6	mason	Petit Larceny	m	21	"	—
15	James O'Conor	" 9	me o Stu	No mack + Drunk	m	31	Irish	—
16	Geo Watterman	" 9	Clyde	Not Wearing mask	m	61	amer	Petaluma
17	Arthur Edwards	" 9	Clyde	" "	m	41	"	
18	Walter Scott	" 9	Clyde	" "	m	47	"	Healdsburg
19	Wm Miller	" 9	Clyde	" "	m	48	"	" "
20	W. R Paget	" 9	Clyde	" "	m	—	"	

The city jail register for November 1918 shows the desperate measures Healdsburg was taking to defend against the deadly influenza pandemic. Town leaders made it an offense for residents to appear in public without an approved face mask. The first arrest on the charge was November 9 and many others followed. The law remained on the books for two months before health authorities said it was safe to remove the masks.

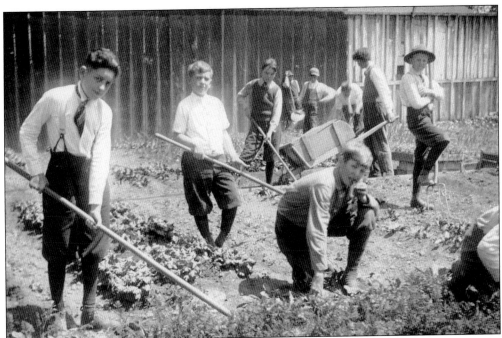

Victory gardens were patriotic demonstrations in World War I as well as in World War II. The idea was to help produce food for home consumption and lessen the demand on the farmers involved in the war effort. The Healdsburg Grammar School provided this example, c. 1918, of boys in town clothes displaying farming skills on the school grounds.

Healdsburg native son Julius Myron Alexander, a descendant of pioneer Cyrus Alexander, is pictured with the banner he designed to promote world peace, prior to the outbreak of World War I. In September 1914, the *Healdsburg Tribune* described "a monster peace gathering" in San Francisco's Golden Gate Park at which his Peace Flag was first unfurled. Sixteen young ladies, in costumes of different nations, marched behind Miss Liberty bearing the Peace Flag. At the peak of the ceremony, they each released a single white dove, while the Peace Flag was waved in front of a crowd of 100,000 people singing "The Star-Spangled Banner."

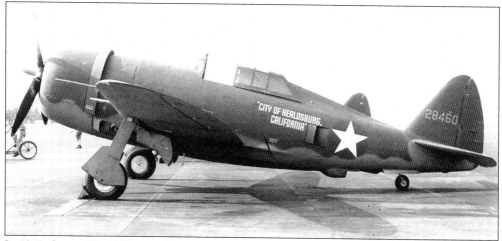

In 1943, during World War II, the elementary schoolchildren of Healdsburg led a bond drive to "buy" a military aircraft. The goal was $75,000 worth of bonds, but with enthusiastic community support, the final pledge came to $105,000. As a symbolic reward, a P-47 Thunderbolt fighter was christened the *City of Healdsburg*. After a successful war bonds tour of America, the plane went to England and the 8th Air Force, assigned to the 352nd Fighter Group.

In 1954, Civil Defense Ground Observer Corps volunteers received a new acoustic detector. Robert Mascherini, far right, shows the device, one of five in California, to observers at the Tayman Park post. Observers pictured, from left to right, are Mrs. Charles Scalione, Mrs. Waldo Iversen, Mrs. W. A. Archer, Mrs. Mel Wood, and W. A. Archer.

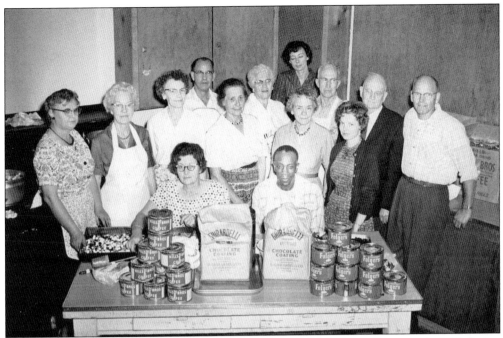

Healdsburg adopted the First Battalion of the U. S. Army's 7th Infantry Regiment in 1951 during the Korean War after the commander, Lt. Col. Fred Weyand, wrote his wife in Healdsburg about the scarcity of non-military items. Spearheaded by Smith Robinson, here seated right, the town's campaign produced a first shipment of tinned snacks, washcloths, combs, mirrors, sewing kits, stationery, and Brownie cameras. Citizens gathered together to bake cookies and prepare packages for the battalion. Also included were the addresses of local girls who would correspond.

Packages shipped from Healdsburg arrived in time for Christmas 1952 distribution to members of the First Battalion, 7th Infantry Regiment. Here Cpl. Vernon Wilmer, left, of Baltimore, and M. Sgt. George T. Petty, of Scottsville, Kentucky, look over part of that 42-package shipment. Healdsburg's "adopted" battalion could look forward to another shipment of packages at Easter, thanks to Smith "Smitty" Robinson and Healdsburg citizens.

SURNAME INDEX

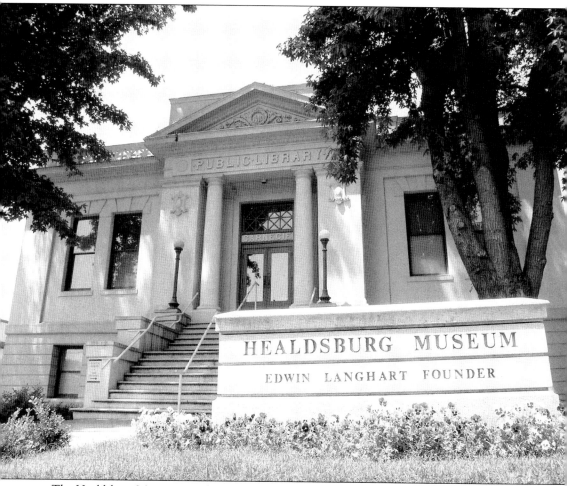

The Healdsburg Museum was founded in 1976 by a group of local citizens led by retired city clerk Edwin Langhart to house historical collections donated to the city. In 1990, the museum moved to its present quarters in the city's Carnegie Library building, dating from 1911. In 1994, the Healdsburg Museum and Historical Society combined to fund and operate the museum. Today the museum, operated by a paid staff and a large contingent of volunteers, is open to the public six days a week. (Courtesy of Daniel F. Murley.)

Visit the museum at 221 Matheson Street, Healdsburg, California

Contact the museum by mail at P.O. Box 952, Healdsburg, California, 95448 or by e-mail at healdsburgmuseum@sbcglobal.net.

Visit the website at www.healdsburgmuseum.org.

History Lives at the Healdsburg Museum.